DRAWING

Robin Capon

TEACH YOURSELF BOOKS

For UK orders: please contact Bookpoint Ltd,
130 Milton Park, Abingdon, Oxon OX14 4SB.
Telephone: (44) 01235 827720, Fax: (44) 01235 400454.
Lines are open from 9.00-18.00, Monday to Saturday,
with a 24-hour message answering service.
Email address: orders@bookpoint.co.uk

For U.S.A. order enquiries: please contact
McGraw-Hill Customer Services, P.O. Box 545, Blacklick,
OH 43004-0545, U.S.A.
Telephone: 1-800-722-4726. Fax: 1-614-755-5645.

For Canada order enquiries: please contact
McGraw-Hill Ryerson Ltd., 300 Water St, Whitby,
Ontario L1N 9B6, Canada.
Telephone: 905 430 5000. Fax: 905 430 5020.

Long renowned as the authoritative source for self-guided learning –
with more than 30 million copies sold worldwide – the *Teach Yourself*
series includes over 300 titles in the fields of languages, crafts,
hobbies, business and education.

British Library Cataloguing in Publication Data
A catalogue record for this title is available from The British Library

Library of Congress Catalog Card Number: On file

First published in UK 2001 by Hodder Headline Plc.,
338 Euston Road, London NW1 3BH

First published in US 2001 by Contemporary Books,
A Division of The McGraw-Hill Companies,
4255 West Touhy Avenue, Lincolnwood (Chicago),
2001 Illinois 60712-1975 U.S.A.

Cover photo from Richard E. Smith
Typeset by Dorchester Typesetting Group Ltd.
Printed in Dubai for Hodder & Stoughton Educational,
a division of Hodder Headline Plc, 338 Euston Road,
London NW1 3BH.

Impression number 10 9 8 7 6 5 4 3 2 1
Year 2007 2006 2005 2004 2003 2002 2001

Contents

Acknowledgements

The author and publishers would like to thank the following for permission to reproduce photographs and illustrations [the numeral references correspond to illustration numbers]: Blackburn Museum & Art Galleries, 158; British Museum, 156 and 157; Rachel Capon, 14, 15, 23, 24, 42, 43, 81, 82, 117 and 118; Pan Macmillan, 27, 69 and 116; Exeter City Museums and Art Gallery, Exeter, 154; and Windsor Castle, Royal Library, 155.

Introduction

Drawing is a very enjoyable and rewarding activity and it is a great way to express your thoughts and feelings about things. Learning to draw will enable you to record moments, events, ideas and subjects that interest you and it will also encourage you to be observant and more aware of your surroundings.

When you make a drawing, essentially what you are doing is putting a collection of marks on a sheet of paper. The inspiration for those marks may originate in your imagination or it may come from seeing something that looks exciting to draw. In either case the marks are created by a process that entails translating thoughts and feelings into lines and shapes using a pencil or similar drawing medium.

Looking, thinking and handling a pencil are, in fact, skills that almost everyone can manage, whether they consider themselves an artist or not. So, in theory we should all be able to draw to some extent. But unfortunately drawing isn't quite that easy! Successful drawings will show a strength, experience and sensitivity, and they will communicate an original, meaningful message. Of course observation plays a key part, but so too does interpretation. Consequently learning to draw is just as much a matter of appreciating how to look at and understand subjects as it is of mastering different techniques and effects.

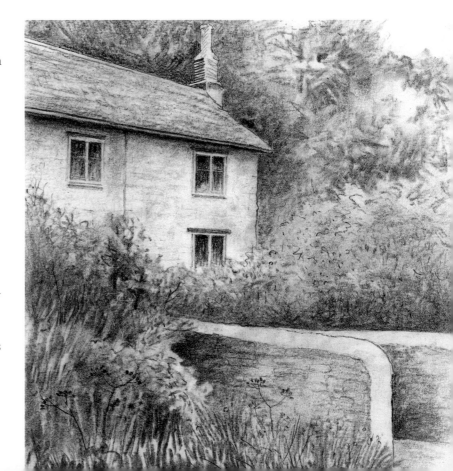

■ Illustration 1. You will need to build up a knowledge of a wide range of media and techniques to help you convey exactly the sort of effects you want in your drawings.

While drawing is an art form in its own right, equally drawing skills are essential in almost every kind of art and craft pursuit. Therefore you may want to draw purely for pleasure, take up drawing as a serious hobby, or acquire skills that will help you in painting or some other form of artistic expression. Whatever your reasons for wanting to draw you will soon discover that there is an enormous range of tools, media and techniques to choose from. A knowledge and confidence with these will not only help you interpret what you see in a way that best suits your feelings and intentions, but will also provide you with a tremendous scope for individuality and creativity.

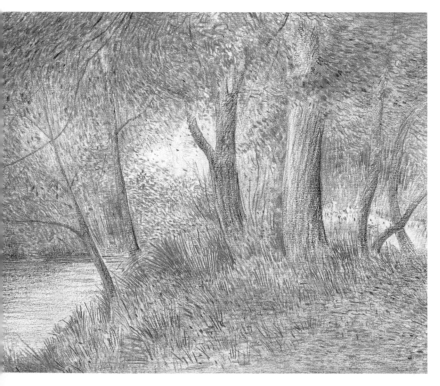

■ Illustration 2. There can be many reasons for making a drawing although, as demonstrated here, maybe none better than because you are inspired by a subject and want to express and communicate your thoughts and feelings about it. This location sketch was made with coloured and water-soluble pencils using mainly line and hatching techniques.

We are all born with the ability to draw. Indeed, the first marks we make are usually in the form of drawings rather than writing. If you study the art and artefacts of any period of history you will see that people have always wanted to draw, for it is a natural form of self-expression. What is more, drawing is not restricted by the frontiers of language: everyone can understand and react to a drawing by Rembrandt, for example, whatever their language.

Because we can all draw, given some time, practice and perseverance, we can improve the way we express our ideas through this versatile medium. Ideally, drawing is a continuous, developing activity. So if you haven't drawn for a number of years you are bound to have lost some skill and confidence. And even if you draw regularly, there are always fresh ideas to explore and new media to try out. But it is never too late to start drawing or to improve your technique.

To draw successfully doesn't just depend on a competence with different media and effects. Drawing involves selecting and interpreting as well as using imagination and employing various procedures and methods. It is a demanding activity, for you need to look, think and draw almost simultaneously. More than anything else it needs enthusiasm and the willingness to try out a variety of methods, and the perseverance to have another go when things do not quite work. The more you draw, the more you will discover about yourself and which techniques and ideas you want to develop further.

There is no such thing as a 'right' way to draw and similarly it isn't possible to define exactly what makes a good drawing, because individual interpretations and preferences play their part. Certainly we cannot measure the success of a drawing purely in terms of the amount of effort and detail lavished on it. A simple line drawing, for example, can have just as much impact as a highly resolved tonal study. This does not mean that you cannot learn from looking at other drawings or by practising exercises and

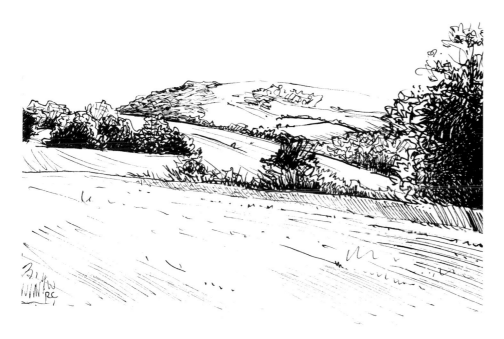

■ Illustration 3. Drawings do not necessarily have to be highly finished and detailed to be effective. Particularly when you are drawing outdoors you may have to work quickly and concentrate on what you feel are the most important qualities in the subject. Drawings like this one will jog your memory and give you plenty of reference information from which to make a more resolved study later if you wish. *Fine fibre-pen.*

techniques. But as your work develops, so all of this experience will be assimilated into your individual way of drawing.

You will find that this book tackles the process of learning to draw in a logical way, beginning with chapters on materials and methods. These will get you thinking about why we draw, the variety of materials that can be used, and the basic techniques. You will discover that an important aspect of learning to draw is learning to see, understand and visually analyse things. From this foundation of information, activities and experience, you will be able to progress to the later chapters in which you can tackle the more challenging aspects of composition and working through different stages, and also find many interesting ideas that will help you develop your own style of drawing.

Using this well-structured approach, you should be able to build on information, examples,

demonstrations, suggestions and topics to improve your drawing skills, whatever your ability. The best way to learn to draw is to have a go for yourself, so throughout the book you will find illustrations and exercises to help you. After studying the text, look at the illustrations and their captions carefully. You may want to start by copying some of these examples as a way of experimenting and building up confidence before tackling the projects listed at the end of each section. These projects encourage you to set up your own subjects and situations using carefully chosen topics that will help you put theory into practice and gain a knowledge and familiarity with the different techniques and processes.

One of the great fascinations of drawing is the variety of possible approaches and interpretations. As you gain experience, don't be afraid to let your own ideas and personality influence your work, and, above all, enjoy yourself!

1

What is drawing?

Defining drawing is no easy task, but what we can say is that drawing involves making strokes or marks on any suitable surface to convey ideas and information. It is, therefore, a means of expression and a method of contact between the artist and other people.

As you work through this book you will notice that drawings can be made in all sorts of different ways and for many different reasons. Depending on the subject and what you want to say about it, you might, for example, choose to draw freely with a brush dipped in ink or work intricately with a sharp HB pencil, and you could decide to use colour or keep to black and white. Sometimes the drawing is just the starting point, perhaps an idea to develop later as a painting, while on other occasions it will make a fully resolved statement in its own right. Drawings can be informative, expressive and decorative, just as they can be funny or serious, therapeutic or intellectual. There are cartoons and illustrations, plans and diagrams, roughs and sketches, and details and studies. A drawing can be scratched in the sand or printed from a computer – the scope is vast.

Contrary to the definition in many dictionaries, drawing is not confined to lines and monochrome. There are many colour drawing media and techniques available today, as demonstrated by various examples in this book. In addition, some drawing methods rely on washes or broad areas and applications of tone, rather than lines.

And you can also make a drawing with a brush. Often, the initial stages of a painting are in fact drawing, this evolving into the reliance on colour and form and the bolder use of brush and paint which is characteristic of a painting. Consequently, the boundaries between drawing and painting are never precise.

In general terms, however, most drawings use line as the principal technique and they are made in black and white. The usual method is to press a soft substance, like pencil or charcoal, on to a harder, receptive surface, like paper, to create a series of marks. Equally, drawings can be made by an intaglio or impressed process, as well as by carving, indenting, spraying and other methods.

When we look at things we see them as form and colour, not in terms of lines. In creating a drawing we are, therefore, frequently assessing what we see and transcribing that image into a series of lines, dashes and dots. Although this process can reach heights of great sophistication, conveying likeness and realism, in practice all drawings must simplify, abstract and interpret what is actually seen.

Vital marks

Many artists think of good drawing in terms of accuracy and realism, and they like their finished works to be as lifelike as possible. Others concentrate on techniques and the means to express. Of course, we can all draw to some extent and, ironically, the ultimate in criticism is 'anyone can make a few marks on a piece of paper'! The trouble is that as we grow up we develop preconceptions and inhibitions which undermine our confidence to draw freely.

Most of us will envy the sheer joy and uninhibited approach that is found in the work of very young artists. There is nothing rubbed out, fussed over, cluttered or overworked here. The drawings of young children are characterised by clear and immediate statements about what is felt. They are acts of communication which are often easier and more successfully made than verbal expression. The marks are vital and telling. What a pity that we have to grow up!

The more you draw the more you will appreciate that successful drawings depend on doing just the right amount of work. A good drawing conveys the

artist's message with some impact yet at the same time often leaves something to the imagination of the viewer. Simple drawings are frequently very powerful. They often imply a good deal which isn't actually drawn, combining this with lines of great spontaneity and energy. See if you can find an illustration in this book that is a good example of this. Learning to simplify is a key element in the process of learning to draw.

But this isn't to say that all subjects must be reduced to a few lines. Often there are very good reasons to render detail, textures and highly accurate shapes. Why you choose to draw something and how you decide to interpret it are obviously important factors in determining the sort of drawing you make. It may well be that to express what you see as the essential characteristics of your subject you need to use a

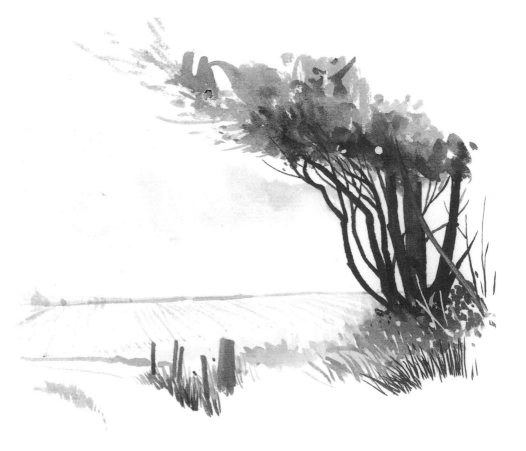

■ Illustration 4. Drawings usually work best if they are not fussed over too much. Try to state just enough in your drawings so that you are conveying your message to the viewer yet at the same time leaving something to their imagination. *Brush and diluted Indian ink.*

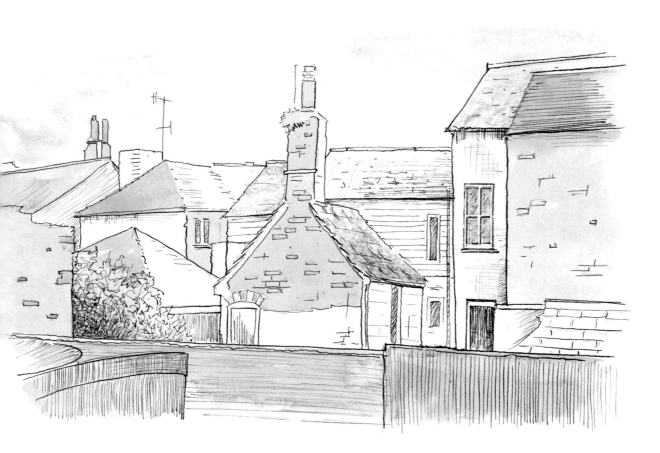

■ Illustration 5. There will always be plenty of ideas and techniques to try out in your drawings, so don't be afraid to experiment and tackle a wide range of subjects. Ideally each new drawing will set you a slightly different challenge and in this way your work will grow in skills and confidence. *Pen and ink drawing with added colour washes and some soft pencil shading.*

variety of techniques and go into a fair amount of detail. However, whether you use a few lines or many hundreds, everything should count and contribute towards the end result. Each mark should be vital.

The language of drawing

There is a well-known Chinese saying that 'a picture is worth a thousand words'. With any drawing, it would take several highly descriptive paragraphs to accurately relate the detail and characteristics of its subject matter, yet we can scan the actual drawing in a few seconds and the message is conveyed almost immediately and most likely with more impact and information. Additionally, of course, the language of drawing is international, a drawing will mean something to us whatever our culture and background.

The fact that we can read a drawing quite quickly need not lessen its lasting value. The best drawings never tire in their appeal and, like any good work of art, we will always find them interesting and stimulating to look at, noticing fresh things to understand and appreciate.

If there is a general language of drawing there are obviously many subtle variations of that language from artist to artist. So, it follows that if we have an affinity towards certain artists or particular drawings it is because we more clearly understand their language.

Furthermore, each artist will employ variations of his or her drawing language according to the aims of the drawing. Working roughs are made to clarify ideas, sketchbook studies to collect information, and the final drawing to resolve thoughts into a visual statement. Each of these stages of working requires a different sort of approach and emphasis.

■ Illustration 6. While the majority of drawings are based on fact and observation, the aim of most artists is to interpret what is there rather than merely record it. Therefore drawings should tell us something about the artist as well as the subject. *Fineline fibre-pen on green calligraphy paper.*

Types of drawing

Mostly we draw to inform or to express. If we want to show what something looks like we are usually objective and representational in our approach; if we wish to show what we feel about something, then we are more likely to be subjective and expressive. This is classifying drawing into very broad types, of course. Drawings are often representational and informative yet not entirely objective, for they are drawn with some feeling. Similarly, a subjective drawing can be full of feeling while still managing to inform.

Drawings which inform normally result from straightforward observation and enquiry. Such

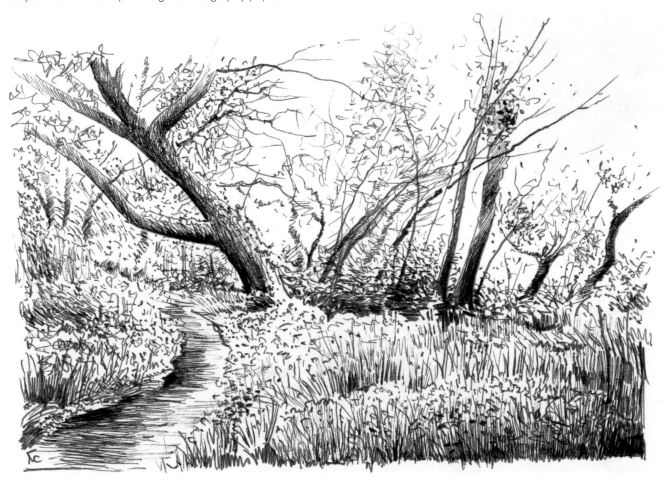

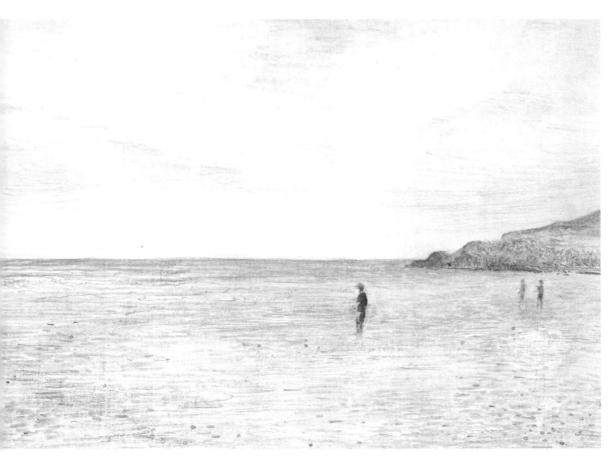

■ Illustration 7. The language of drawing is universal. It is easy to read a drawing such as this, whatever language we speak. As here, drawings can be descriptive and evoke a particular mood, *Coloured pencils*.

drawings aim to create records of fact, and this process is sometimes carried further into detailed analysis. Where the artist's personal response to the subject dominates, emotion is likely to replace quiet observation and results might vary from something which is freely and passionately drawn to works which are non-objective or completely abstract in concept.

Linked to our response to the subject and our aims and objectives for undertaking the drawing is the method best suited to fully realise the idea. Vital to the success of any drawing is the medium we choose and the consequent range of techniques. So, as well as being objective or subjective, representational or expressive, analytical or stylised, decorative or abstract, drawings can also be classified by medium and method: pencil, pen and ink, charcoal, mixed media, and so on. There are also line drawings, tonal

drawings, line and wash, and a range of other techniques. And, as previously mentioned, drawing types may be thumbnail sketches, diagrammatic summaries, roughs, cartoons, details, under-drawing for painting, research studies and large-scale completed works.

So, before you begin a drawing it is wise to plan it in terms of:

■ **approach** – objective or subjective;
■ **method** – pencil, line and wash, etc;
■ **outcome** – sketch, study, highly resolved drawing, etc.

You will begin to understand more about the range of available materials and the different ways of looking and selecting when you have studied the next few chapters.

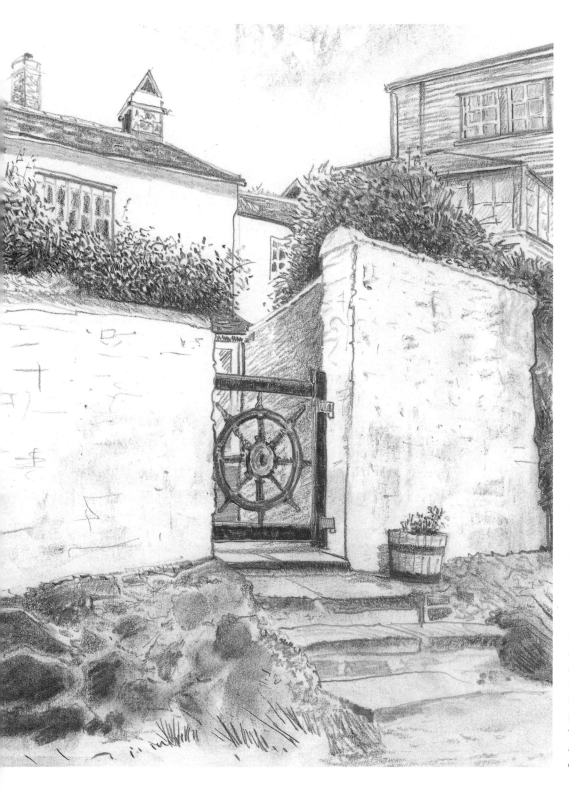

■ Illustration 8. Usually, your initial response to a subject will tell you whether you want to tackle it objectively or subjectively and, in turn, the approach you adopt will be influenced by the medium or media you choose. Where the subject matter involves lots of straight lines, as here, it is often a good idea to use a medium that will prevent you becoming too fussy and precise, for in so doing you will keep the drawing lively and interesting. *Charcoal and charcoal pencils.*

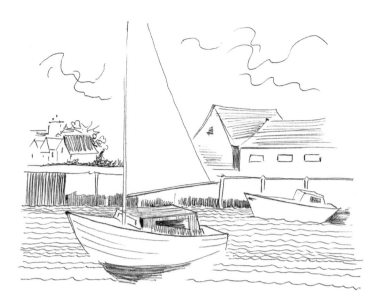

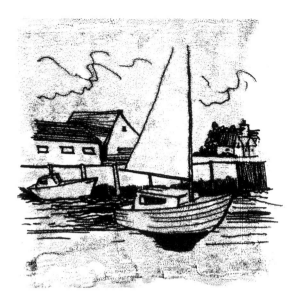

■ Illustration 9. What you choose to draw with and the sort of paper you use will have a profound effect on the success and impact of the drawing. You can test this out by making two drawings of the same subject, using a different medium for each one. This drawing was made with a ball-point pen – compare it with the drawing on the right.

■ Illustration 10. You will notice a general similarity between this drawing and the one on the left, but there are also some differences. This drawing is bolder and has a more textural quality and, of course, it also shows the subject matter the other way round – reversed left to right. The technique adopted here was rather different from that used in the previous drawing. This is a monoprint drawing and it was made by placing the paper over a sheet of glass covered in printing ink, drawing the scene on the paper with a sharp pencil, and then lifting the paper off to reveal the reversed and more interesting drawing on the back.

Why do we draw?

From cave art to computers, people have always felt the need to draw. It is a natural form of expression and communication. We draw out of curiosity and interest, to help us understand things, solve problems, get information or resolve ideas. Ideally we draw because there is an urge, an inspiration, a desire to commit ideas to paper. It is a great way of showing what we think and feel about things.

Drawing isn't always easy: it can be very demanding and difficult. But it should always be rewarding. Already you will have an indication of the exciting scope of drawing. Whatever philosophy you evolve towards the subject you will find that there are plenty of ideas and techniques to choose from – something for everyone. And the more involved you become with

drawing and the more you practise, the greater will be your enjoyment. You will soon discover that tremendous sense of achievement and satisfaction when a drawing is completed and it exactly states your intentions. What's more, a successful drawing will help to generate the enthusiasm and energy to tackle the next idea, which of course will be even better!

However, to draw well depends on a number of factors and qualities, not least of which is self-confidence. Drawings always seem to work best if they can be expressed freely and positively. Naturally it will take you a little time to build up some confidence, for this will rely mainly on your experiences of different media, techniques, and drawing subjects and

situations. In this context the best advice I can give is to be patient and persevering. Obviously in trying out various ideas and approaches you will make mistakes and there will be frustrations and disappointments to overcome before you can start to show real progress.

But the challenge of drawing is part of its attraction. If you try to make it easy by sticking to simple methods and familiar subjects then all you will do is turn it into something which is routine and pointless. Drawings that are made to a formula will lack the essential element of originality, and this not only in the sense of your individual technique but also regarding what you choose to draw and how it is interpreted. Ideally, each new drawing should be slightly different from the last, setting a fresh challenge and arousing your interest and motivation.

This is not to say that you cannot return to a subject or have a favourite theme. Indeed, it is possible to successfully draw the same thing over and over again, providing it continues to capture your imagination and offer something new each time you tackle it. What you must not do is stick to the same subjects simply because you fear failure, for this will seriously inhibit the opportunities to explore and experiment, which in turn will greatly restrict your development.

As for mistakes, it won't be long before you start to appreciate that they can actually point the way forward. Rather than seeing them only as a negative element of your work, you will find that you can in fact learn from your mistakes. As long as you are able to be self-critical and are willing to address the weaknesses in your drawing, then mistakes shouldn't matter too much. If you find a problem, then take steps to solve it. Refer to the relevant section of this book and, most importantly, practise and experiment.

What can we use?

It is obvious that most drawings can be done very simply. Unlike many art techniques, drawing does not need a lot of complicated equipment and expensive materials. Indeed, this is often proven when you are out somewhere, see a splendid subject to draw, but do not have any obvious drawing equipment with you. I have made drawings on a brown paper bag, on a blank page at the end of a paperback book, on lined paper . . . even on a car parking ticket!

Most drawings are made with pencil on paper. While this is suitable for many ideas, don't be afraid of being adventurous and of experimenting. A drawing tool need not necessarily be something that was specifically designed for drawing! As well as the more traditional shop-bought implements, there are plenty of unconventional ones, either found or home-made, that can be pressed into useful service. You can achieve interesting effects by applying wet-medium textures with a cork or comb, for example, creating a spattered or stippled texture with a toothbrush, or drawing with your finger or a stick dipped in paint or ink. Playing safe isn't always the best approach and, as has been stressed, you will need to consider which medium and technique will be the most appropriate for the idea you have in mind. Try to familiarise yourself with as many different drawing materials and methods as possible. Charcoal, pastels, crayons, pens, inks and other materials are introduced in the next chapter, and in the subsequent chapters you will see many ways of using these materials.

Exercises

1. Start a drawing scrapbook. Keep in it any postcards and cuttings of famous drawings, photographs of subjects and ideas that appeal to you, and any other visual material which could inspire drawings. Aim for a wide choice of material. In time this will form a very useful reference aid along with your notebooks and sketchbooks.
2. Next time you are near an art gallery, pop in and look at any drawings they may have on display.

2

Materials and equipment

The first step towards developing your drawing skills is to gain some familiarity and confidence with a wide range of drawing tools and materials.

You will soon find that each medium has its particular strengths and characteristics and that these, in turn, will help you create certain effects. As you gain experience you will be able to choose the best medium for the type of drawing you want to make and, when appropriate, even combine a variety of media. Read through the whole of this chapter first and then study each drawing medium in more detail. Collect together as many different tools and materials as you can and test these out by completing the various exercises listed at the end of this chapter. Try colour as well as black and white techniques. To help you with some ideas, have a look at the colour drawings included throughout this book.

Pencils

When you are buying pencils always look for good quality graphite drawing pencils made by well-known manufacturers such as Derwent, Faber-Castell, Stabilo and Staedtler. These are marked to indicate their degree of hardness, which may range from 8B to 9H, with grades HB and F midway between the two. Very

hard pencils, that is those in the 'H' range, are not normally suitable for general drawing. They cannot be handled with the same sensitivity as softer pencils and tend to indent the paper, thus making it difficult to erase lines that are wrong. Keep to a softer range to begin with. A selection comprising B, 2B, 4B and 6B is recommended, supplementing this with an HB if you need to make sharper, more defined lines or greyer and weaker tones.

One of the first things you will notice is that pencils respond to the pressure you apply. Some people naturally work more confidently and positively than others. Your range of pencils will need to match the way that you work so that you can achieve a good balance of tones and lines from very dark to very light. Also, the response from a 2B pencil, for example, may vary from one brand to the next. So try out several makes and when you have found a type that handles well, stick to it. You will also find that the sort of paper you choose will influence the effects you can achieve and the way that pencils and other materials respond.

Perhaps because it is so familiar to us, the ordinary

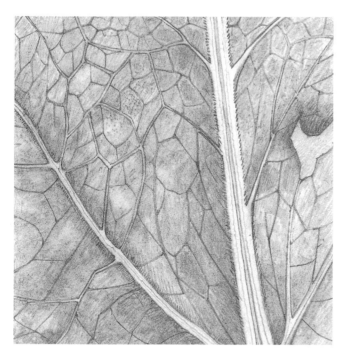

■ Illustration 11. When necessary, pencils will allow a lot of precision, so that you can really analyse surfaces and structures, as in this leaf study.

pencil is often underrated as a serious drawing implement. Yet it is one of the most versatile of all drawing media and the one which will most obviously reflect your drawing ability. Pencils suit everything from composition roughs to highly expressive drawings made on the spot. Use them for jotting down quick visual 'notes' and ideas as well as for problem-solving, analytical studies and reference sketches. And remember that they are extremely user-friendly: they combine well with most other media, especially watercolour, inks and charcoal.

Modern graphite pencils are manufactured from natural graphite that has been made into a paste by blending it in a powdered form with clay. The paste is then compressed and extruded into thin strips, which are subsequently dried and kiln-fired to make the leads. These are impregnated with waxes to make them draw smoothly, glued into a casing of soft wood, and finally finished with one or two coats of paint.

You can supplement your basic drawing pencils with wide carpenters' pencils and graphite sticks, both of which are ideal for laying in very broad areas of tone and working on a larger, freer scale. And don't forget, of course, that you can also work in colour, using coloured pencils, water-soluble pencils and pastel pencils. Look at illustrations 9 to 15 to see how pencils suit a variety of approaches and subject matter.

■ Illustration 12. Try some quick sketches and studies using just a 2B pencil, as demonstrated here. Keep the pencil sharp for any thin lines and delicate marks you want to make, and contrastingly use the lead on its side for broad areas of tone, like the shadows in this drawing. Remember too that the amount of pressure you apply will affect the strength of the various pencil lines.

■ Illustration 13. This sketch was made with a carpenter's pencil, using both broad and thin strokes to create different effects.

Coloured pencils

All the main manufacturers market coloured pencils, but there are differences, if sometimes subtle, between one make and the next. As coloured pencils are sold individually as well as in sets it is a good idea to buy just one or two colours from several brands so that you can make comparisons. Some, you will find, are more brittle and harder than others, giving sharper, firmer lines but weaker and less blendable colours. You may prefer a mixture of different makes so as to increase the range of possible effects. But keep to a limited palette (range of colours), especially for location sketching. Colour reference sketches are essential for ideas which you want to develop into more resolved paintings later on and coloured pencils are a very controllable and useful medium for these. Additionally they can be used for all types of subjects and interpretations, including very detailed studies. Some of the softer colours will smudge and blend a little and colours can, of course, be intermixed by hatching or laying one colour over another.

Similar in appearance to coloured pencils are water-soluble coloured pencils, which are also known as watercolour or aquarelle pencils. You can use these just like ordinary coloured pencils, applying them as dry colour, but they have the added advantage that areas can be wetted and transformed into a wash or another 'watercolour' effect. Work on 190 gsm or a heavier quality watercolour paper with these pencils. Lots of different techniques are possible, for example drawing on damp paper to give a blurred, atmospheric quality, or adding detail with a sharp pencil over a wash area. Out in the landscape, water-soluble pencils are ideal for capturing something of the mood of the scene,

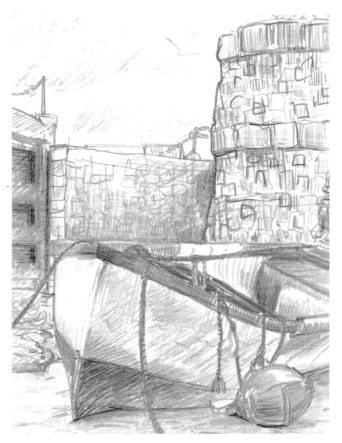

■ Illustration 14. You may want to add some colour to your pencil drawing so, as here, use an ordinary graphite pencil to establish the general outlines of the subject and then work over these in colour. Keep to just two or three different colours.

■ Illustration 15. As in all aspects of drawing, try not to overwork the use of colour. Do just enough to suggest the colours that are there.

■ Illustration 17. With water-soluble coloured pencils you can wet areas and so create contrasts of wash and line effects.

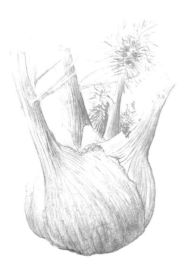

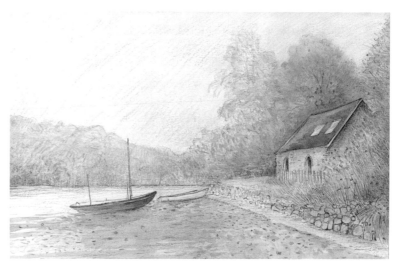

■ Illustration 16. Variations of colour can be achieved by shading one colour over another or by altering the pressure on the pencil.

particularly where sky and water areas are involved. Other techniques include building up strong, rich colours and textures by working over an initial colour wash, wetting and modifying colours where necessary with a soft brush dipped in clean water, and lifting out colour by wetting an area and then dabbing it with some tissue paper.

Pastel pencils are another excellent sketching medium. In fact, they are more convenient to carry around and less likely to break than the soft pastel sticks, and this makes them a good choice for outdoor subjects which require both control and versatility in approach. With pastel pencils you can lay in broad areas of colour, combining these with whatever definition and detail is required. And because they are made from pure pigment powder, pastel pencils are ideal for blending and creating quick atmospheric effects. Like true pastels, colours can be overlayed and rubbed together, and you can even wet them to give other interesting wash, textural and surface qualities.

The different pencil drawings in this book prove the range and versatility of this medium. At the end of this section you will see that I encourage you to test out all your materials to find out just what variety of lines, dots, dashes, tones and other effects they can give. I hope you will be keen to go further than this and make some small pencil drawings of your own, inspired by the accompanying examples. Bear the advice, information and instruction in mind as you draw. But the great thing about drawing is that you learn from experience – so have a go!

Charcoal

Compressed sticks of willow charcoal are produced by firing willow rods in a kiln until the wood is carbonized. You can buy boxes of mixed thicknesses, from very thin to thick scene-painters' charcoal. A few sticks are always useful, especially for sketching and loose, large-scale work, as well as for creating greys, diffused shading effects and various textures and dabs of tone in conjunction with other drawing techniques.

Initial experiments with charcoal can be rather disappointing, so persevere! Charcoal sticks are brittle, need sensitive and careful handling to create fine lines and controlled work, and can be messy. However, when more positive lines and details are required stick charcoal can be combined with charcoal pencils. These

■ Illustration 18. Charcoal is an excellent medium for quick, spontaneous drawings. This drawing was made with a single stick of charcoal, holding it at various angles to create marks of different thickness and intensity.

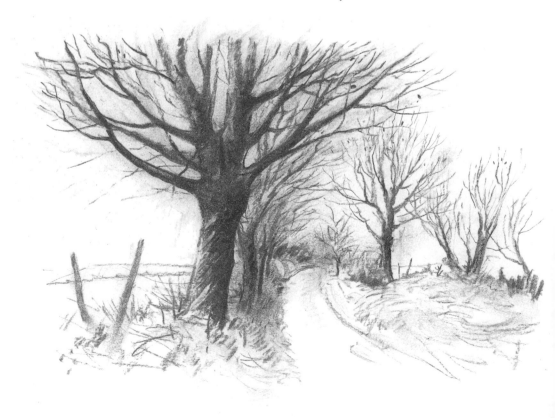

■ Illustration 19. To enhance the texture in a charcoal drawing, try using a rough-surfaced paper. If you work on watercolour paper you will be able to add one or two touches of colour in the form of weak watercolour washes.

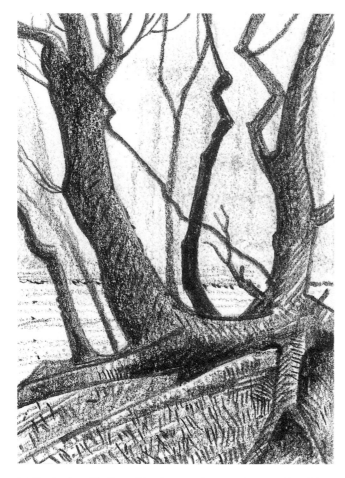

■ Illustration 20. Broad background areas drawn with stick charcoal can be contrasted with more precise lines and details made with a charcoal pencil.

first and experiment with smudging it in different ways: with fingers, a cotton bud or a small piece of cloth or paper. You can also use the charcoal on its side for broad tones and general textures. Completed drawings will need fixing.

Charcoal is splendid for sketchbook work and getting a quick impression or feeling for the subject. Have a look at illustrations 18 and 20. The sketch in illustration 18 was done with a single stick of charcoal and shows the immediacy, liveliness and spontaneity of this useful medium. Contrastingly, much of the drawing in illustration 20 has been done with a charcoal pencil, using stick charcoal only for the general background tone. Charcoal also combines well with colour washes. Mix a watercolour or ink wash and apply it sparingly to the charcoal drawing, as demonstrated in illustration 19.

Pastels

White chalk or pastel is ideal for use in conjunction with charcoal to create highlights and contrasts. Other colours can be purchased individually or in boxes of an assorted range.

Learn to distinguish soft pastels, which are like chalks and easy to blend and smudge, from oil pastels, which behave more like wax crayons. On most papers, oil pastels will give rich, solid areas of colour. They are not easy to intermix or erase. Soft pastels, on the other hand, can produce the most delicate of lines as well as subtle chiaroscuro (light and dark) and blended colour effects. Do some experimenting, as recommended for charcoal, so that you get a feel for this medium before attempting one or two drawings.

Soft pastels are made from dry pigment mixed with a binder, such as gum arabic or gum tragacanth, and a preserver and extender. Round and square varieties are produced, both in the form of sticks about 5 cm long. The square pastels are firmer, making them suitable for detailed linear work as well as broad areas of

are available in soft, medium and hard degrees, can be sharpened to a point and, if used with restrained pressure, will behave in a similar way to ordinary pencils.

As an introduction to using charcoal, break off a length of about 4 cm and try a few simple exercises. Hold the charcoal at various angles and apply different pressures to see what variety of lines and tones you can achieve. Try it on smooth as well as heavier quality paper and even coloured paper. Apply it sparingly at

colour. Also available are pastel pencils (see page 16), which are useful for adding more precise lines and edges, and small marks and accents of colour. Pastel colour is opaque.

The general principle with all of these chalk and crayon techniques, indeed with most drawing techniques, is to start with the weak tones and lines and build up the thickness and intensity of the medium gradually. Mix colours either by alternating a line of one colour with another and then blending the two together with a finger or small piece of cloth or paper, or by working one colour over another. Blow away unwanted dust and 'lift' mistakes with a kneadable or putty rubber.

Several soft pastel and pastel pencil techniques were used in illustration 24 on page 20. Here the main

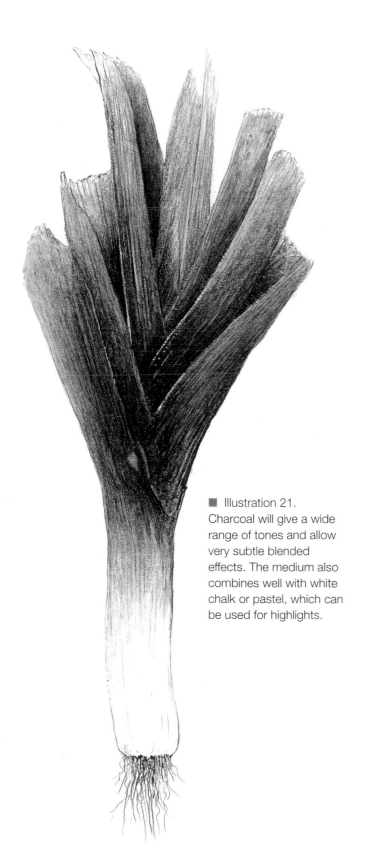

■ Illustration 21. Charcoal will give a wide range of tones and allow very subtle blended effects. The medium also combines well with white chalk or pastel, which can be used for highlights.

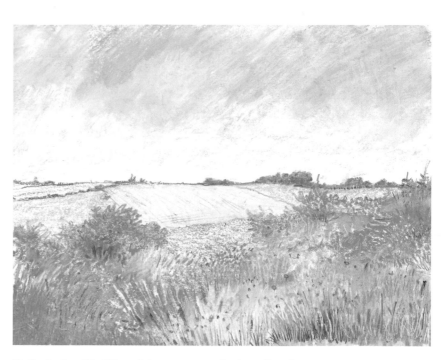

■ Illustration 22. Oil pastels are an excellent medium for location sketches, because they won't smudge and they can be used in a very direct way.

■ Illustration 23. Like charcoal, pastel is a very sensitive drawing medium. You can make bold marks or quite delicate ones, depending how you hold the pastel and how much pressure you apply.

shapes were drawn weakly in pastel pencil. Next the general tones were applied with soft pastel and this was subsequently worked into and over with more deliberate lines and areas of shading using a mixture of pastel pencils and pastel sticks.

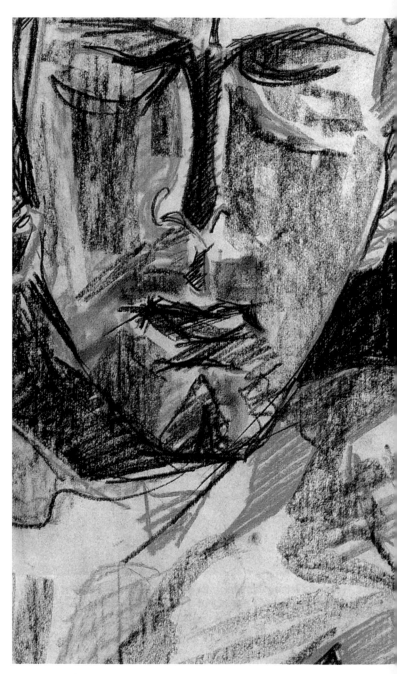

■ Illustration 24. Pastels are great for this sort of vigorous drawing. Here, general areas of colour applied with sticks of soft pastels have been combined with more defined lines made with pastel pencils.

Crayons

Under this heading there are two rather different types of crayon: wax and conté. Wax crayons are often associated with children's drawings and are most suitable as a sketching and 'fun' medium. By contrast, conté crayon techniques are best known through the drawings of a few famous artists, like Seurat.

Wax crayons are cheap and a box of assorted colours makes an interesting addition to the range of drawing materials. They can be used for rubbings, quick sketches and a variety of wax resist techniques.

Conté crayon is a hard, grease-free drawing chalk that is usually applied to heavy quality paper. Like wax crayon, it does not smudge and consequently does not need fixing. It can give lines of great sensitivity as well as dramatic tonal effects. Both types of crayon can be sharpened to create fine lines and, like pastel and charcoal, the sticks can be used on their side for general shading.

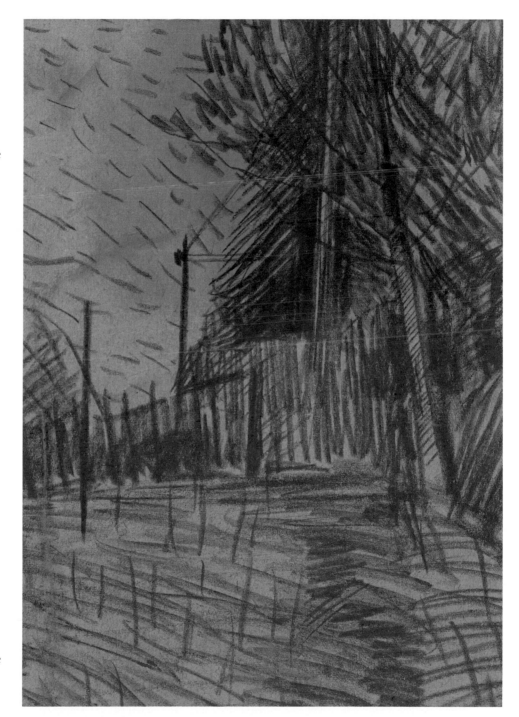

■ Illustration 25. This expressive drawing was made with a brown stick of conté. These crayons are most effective when used on a tinted paper with a slightly textured surface, as this brings out the character of the marks.

Pens

These are also inexpensive, so make a collection of as many different kinds as possible. Look out for mapping pens, script pens, technical pens (like Rotring and Faber-Castell), special art pens and sketching pens, cartridge pens, ball-point pens, brush pens and fibre and felt-tip pens. Dip pens, like mapping and script pens, will need some drawing ink. Other pens have their own built-in supply of ink or, as is the case with most technical pens, come with a replaceable cartridge of ink and interchangeable nibs. Additionally, you can experiment by making your own dip pens: sharpen sticks of wood or make a quill.

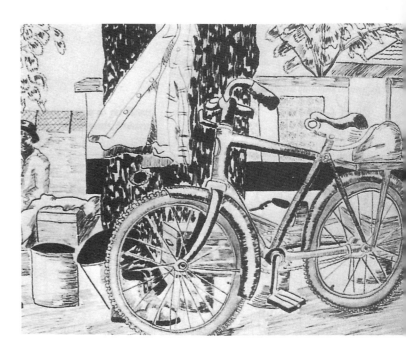

■ Illustration 27 (right). Pen and ink drawing can have great impact. This lively drawing was made by a secondary school student in Botswana.

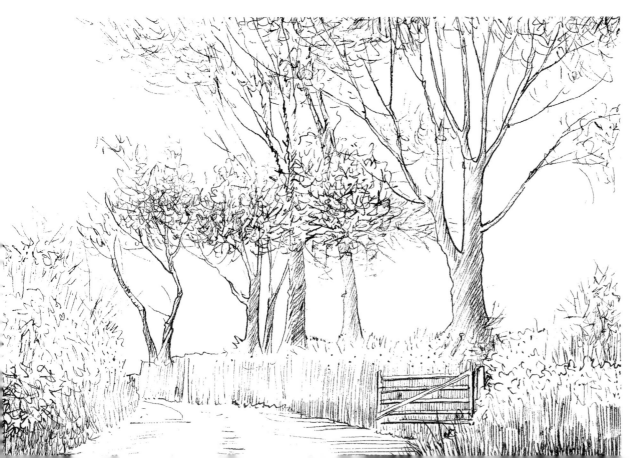

■ Illustration 26 (left). Although there are many different types of fineline and fibre-tip pens available today, don't overlook the traditional dip pens. This drawing was made with a mapping pen and diluted Indian ink. Where fine lines are required, as here, try not to overload the pen or use it too vigorously – pressure and touch are all-important in creating lines of the correct strength.

Each type of pen will give a certain character of line or range of techniques. Dip pens tend to be the more unpredictable since they do not have the controlled flow of ink that a reservoir pen has. Arguably this gives scope for drawings of greater verve and personality, like the reed pen drawings of Van Gogh. Again, it is a question of trying out each kind of pen to see what lines and marks it can make, and so discover which type suits you best. Remember to test each one on some different papers.

Many pen techniques are ideal for sketchbook work and quick studies. Look at illustration 26, for example, which was made with a mapping pen, and the felt-pen and wash drawings in illustrations 28 and 102. Note, too, that drawings do not have to be detailed and elaborate to be effective.

Inks

You will see quite a few drawings in this book which have been made with Indian ink, sometimes diluted with water. The ink can be applied with a pen or a brush as specific, direct drawing, or with a brush or sponge for background wash effects. Ink is also used in various spraying, spattering sgraffito and texture techniques, as explained in Chapter 5. Additionally, coloured drawing inks increase the range of possibilities and thin ink washes can be combined with other drawing media and methods.

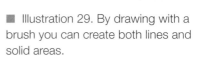

■ Illustration 28. Water-soluble fibre-tip and felt-tip pens work very well over watercolour washes, and lines and marks can be softened by wetting them with a brush dipped in clean water. Allow the initial washes to dry before drawing over them with the pens.

■ Illustration 29. By drawing with a brush you can create both lines and solid areas.

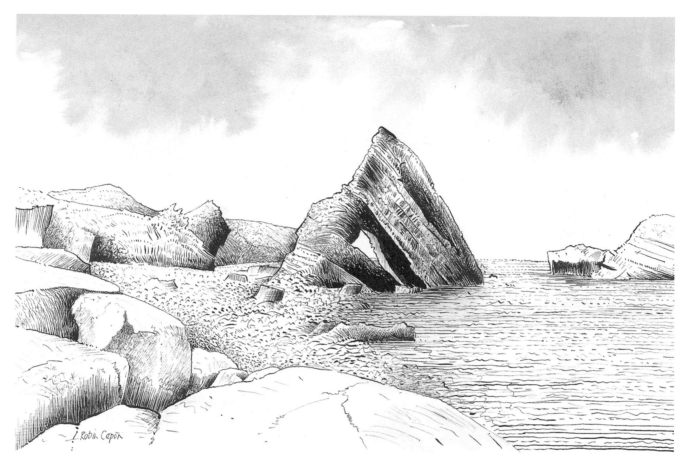

■ Illustration 30. A pen and wash drawing using a mapping pen and very diluted washes of Indian ink.

Start with a small bottle of Indian ink as part of your basic stock of materials. As you gain confidence with this so you can add coloured inks later. Investigate some line drawing techniques using a mapping pen and one or two different brushes. Mix a few drops of ink with a lot of water to make a thin wash. Try applying the wash with a flat watercolour brush or a sponge.

Note the way that light and dark areas have been created in the ink and brush drawing shown in illustration 29. The drawing in illustration 30 was made with a mapping pen and Indian ink. The sky effect was made by applying a thin wash of ink to dampened paper.

Other drawing tools and materials

Drawing tools do not always have to be conventional. When you have mastered some of the basic techniques and have started to explore drawings as a personal way of expressing your ideas, you may find that some rather unusual items help in the way you want to work. For example, as well as adapting and modifying tools like brushes and pens, you could try creating texture effects by using part of an old comb or a toothbrush dipped in some ink. You can make unusual drawings by applying a colour wash over lines made with a clear wax candle or by blowing droplets of ink across the paper through a drinking straw. So, don't be afraid to experiment in order to add to your drawing skills; drawing can be fun!

Interesting drawings can also be made by using items such as a spent ballpoint pen to indent marks into the

■ Illustration 31 (above). You can add interesting textures to your drawings in all sorts of ways. This texture was created by dipping part of an old comb into some drawing ink and then dragging it across the paper in various directions.

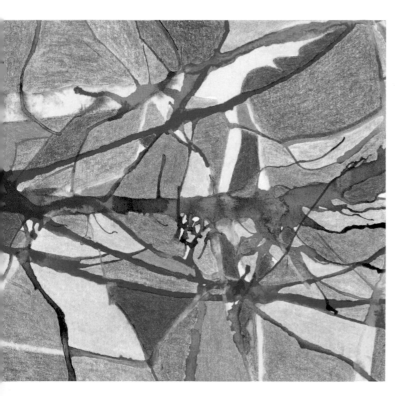

paper. When these marks are shaded over with a soft 6B pencil they will show up quite clearly. For another alternative technique, try applying small blobs of ink to a sheet of paper that has been propped up at an angle, and then blowing these around using a drinking straw blowpipe. This is how the main part of the drawing in illustration 32 was made. It has created an exciting design for an abstract drawing in which the resulting shapes have been blocked in with coloured pencils.

■ Illustration 32 (left). Having fun with different media like this will help you understand their qualities and potential. The lines were made by blowing ink across the paper, using a drinking straw as a blowpipe, and then the spaces were filled in with coloured pencils.

Many people regard drawing as a technique which is distinct from painting but, in fact, the two disciplines often overlap. You can draw with a brush dipped in paint and you can add tints of weak colour to develop line drawings made in pencil or ink. A small box of watercolours or a few tubes of gouache or watercolour paints can therefore extend the scope of your work. Add to these two or three different sized watercolour brushes and a large flat wash brush.

Paper

You will need a stock of good quality cartridge paper. The thickness and quality of paper is indicated by its weight in grams per square metre (gsm).

Sheet sizes are now mostly standardized to ISO (International Organization for Standardization) paper sizes. Each size in the list below is exactly half of the next:

- A4: 297 × 210 mm;
- A3: 420 × 297 mm;
- A2: 594 × 420 mm;
- A1: 840 × 594 mm.

The type of paper will greatly influence your drawing and the way that different tools and media respond. The following papers are recommended:

- 150 gsm cartridge paper will suit most pencil drawings, dry colour drawings in crayon and some ink techniques.
- 180 gsm (or heavier) cartridge paper is best for very soft pencil effects and charcoal work.
- Use a smooth art paper, thin card, layout paper or non-bleed marker paper for work in pen and ink, fibre and felt-tip pens.
- Ingres papers, Canson Mi-Teintes paper and cheaper sugar paper (in various colours) are the most suitable for chalks, pastels and heavier charcoal work.
- 300 gsm watercolour paper is required for washes, brush drawings and tinted and painted work.

Keep samples of a wide range of different papers so that, if necessary, you can do a few tests with any medium prior to drawing. For some wet techniques the paper will need preparing in the way described on page 97.

Paper is said to have a 'right' and a 'wrong' side. Of course, either side can be used, though for most drawings the correct side will be the one with the uneven surface. To check this, hold the sheet up to the light and bend over one corner: one side should have an even, mechanical surface, the other will be uneven.

Additionally, you will need a pocket-sized sketchbook in which to jot down day-to-day ideas and notes, and a larger, A4 sketchbook for more resolved drawings and studies, experiments with different media and techniques, composition roughs, and so on. More details can be found in Chapter 8.

Some sheets of tracing paper are also useful. You will find it cheaper to buy large sheets of paper and cut them down to size. Store all papers flat.

Erasers

There are several types of eraser, with each serving a slightly different purpose. As erasers are inexpensive it is well worth buying one of each type.

Plastic and kneadable (putty) erasers are the best general purpose types for, unlike the traditional India-rubber erasers, they are far less likely to damage the paper surface, even when used on soft, fibrous papers such as the heavier quality watercolour papers. Use a plastic or vinyl eraser for pencil drawings and a kneadable eraser for creating more subtle tones and blending effects in charcoal, pastel, chalk and soft graphite media. As the name implies, kneadable erasers are very malleable and are easily broken and shaped to suit the techniques you have in mind, whether erasing, blending, adding soft tones or creating highlights. Also, for fine, detailed work, you can pinch the putty eraser to form a point.

Another very useful type of eraser is the eraser pencil or rubber-tip pencil. Try this for adding small accents of light and tidying up details, as well as to draw 'in negative' by removing lines and shapes from solid areas of tone or colour. Additionally, of course, there is the traditional, flexible India-rubber eraser, which is made in a variety of shapes and sizes, including a very useful wedge-shape. Like plastic and kneadable erasers this is versatile and can be used on most media. However, you should take great care if you use it on soft or obviously textured papers as it may scuff the surface.

Erasers are an important drawing tool in their own right, and they will be especially useful when you are working with contrasts and subtleties of light and dark in drawings. Some eraser techniques are explained in Chapter 4.

Ancillary equipment

The following drawing aids and items of ancillary equipment are essential:

- A sharp **craft knife** for sharpening pencils, cutting paper, scratching into wax, etc.
- **Fixative**. Choose ozone-friendly aerosol cans and use in well-ventilated conditions. Spray this on charcoal, pastel and any other finished drawings which are likely to smudge.
- **Clips and pins**. Use bulldog clips, drawing board clips or drawing pins to secure work while in progress.
- A plastic bevelled-edged **set square** or ruler.
- Metal blowpipe **diffuser**. For simple ink and paint spraying techniques.
- **Paper tissues**, cotton buds and cotton wool. For modifying and blending soft media like pastels and for various paint and texture techniques.
- A roll of 5 cm brown **gummed tape** for stretching paper.
- A **drawing board**. Proper art boards are expensive. Buy a sheet of 9 mm plywood which is slightly larger than an A2 sheet of paper. You can, of course, have smaller and larger boards as well!

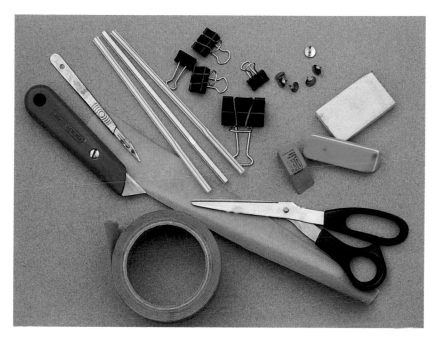

■ Illustration 33. Some useful drawing accessories.

See how your work progresses before buying any other equipment. If you enjoy working outside you may eventually want to buy a sketching easel and folding stool, for example.

Additionally, it is always useful to have a sturdy folio to keep your work in, or to be able to store it flat on shelves or in a plan chest. If you are fortunate to have your own room, studio or workspace of some description, you can gradually invest in the right equipment and work facilities.

Choice of materials

A recommended basic checklist of materials is included on page 28. Try them all out and get to know something of their characteristics and potential. You will find that you like some media more than others. This is fine to begin with while you are learning techniques and gaining confidence. But don't just stick

to pencil drawings and do remember that there are many colour drawing techniques.

Although some of the materials will not be put to immediate use, have them ready. Nothing is more frustrating than wanting to try out a particular effect only to find that you do not have the necessary materials in stock!

Your drawings will improve only if you are prepared to take risks and consider new ideas and techniques. Repeating the same old subjects in the same old way will not get you very far. The more experience you have of a wide variety of materials and techniques, the better equipped you will be to choose the best way of expressing your ideas.

Buying materials

Go to a reputable artists' materials shop where you should also be able to get some good advice and test out the samples and products you are interested in.

Here is a recommended 'starter' shopping list. You can add to this as the need arises.

- 10 Al sheets of 150 gsm cartridge drawing paper. You can cut this to any shapes and sizes you need.
- Two Al sheets of 180 gsm [or heavier] cartridge paper.
- A few sheets of buff, cream, and grey pastel paper or sugar paper.
- Two large sheets of 300 gsm watercolour paper.
- An A4 spiral bound cartridge sketchbook.
- A small notebook with smooth plain paper or a pocket-sized sketchbook.
- HB, B, 2B, 4B and 6B drawing pencils.
- A kneadable and plastic eraser and a rubber-tip pencil.
- Some water-soluble and coloured pencils. You can buy them separately, starting with just a few colours to try out.
- A box of stick charcoal and a medium charcoal pencil.

- A small selection of soft pastels. Colours bought separately are cheaper than buying a whole box.
- A box of wax crayons.
- A fine fibre pen (black); a marker pen (black) and a fine mapping pen.
- A small bottle of Indian ink.
- No.2 and no.4 watercolour brushes; a no.6 round hog brush.
- One or two small tubes of gouache or watercolour paints. Just stick to red, yellow and blue to begin with.
- The essential ancillary equipment listed on page 27.

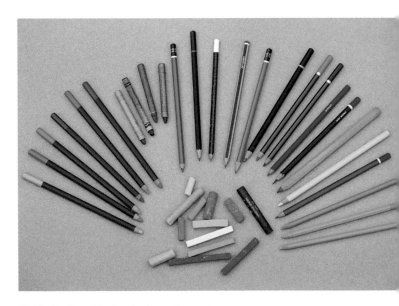

■ Illustration 34. A selection of pencils, wax crayons, soft pastels and oil pastels.

Testing out your equipment

Now that you have learnt something about the range of drawing materials and have collected a stock of your own it is time to do some testing and experimenting. As you work through the different sections of this book you will see that artists are fond of making roughs and preliminary sketches and trying out different ideas and techniques before they make their final decisions for the main drawing. This is a good habit to get into.

Keep all of your drawings for future reference and comparison. Although you may not want to show most of them to anyone else, they are useful for you, to demonstrate what progress you have made. Media tests and experiments should be labelled to identify which drawing tool or material was used, plus one or two brief notes on the effects you tried out.

Now try the following exercises.

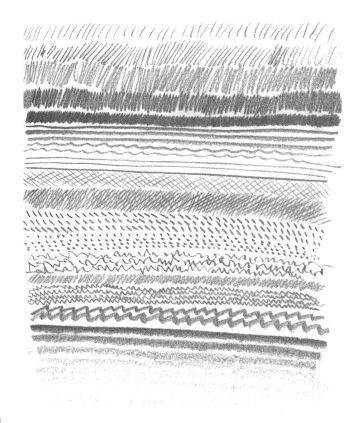

■ Illustration 35. Try an exercise like this to test out your pencils and see what lines and effects are possible.

Exercise

1. Work through all the drawing media in your collection, starting with pencils. Using a new A3 sheet for each medium, see what range of marks, shading effects and textures you can make. Try holding the drawing tools in different positions and using various pressures. Fill the sheets with notes and experiments in this way.

My test piece using a 6B pencil, shown in illustration 33, will give you a starting point. Note how I have varied the angle and pressure of the pencil to see how this affects the lines I am drawing, starting with the pencil held vertically and finishing with it used on its side, and how a variety of line effects, from wavy to hatched, can be achieved. Look also at illustration 36, where I have tested out some effects with oil pastels.

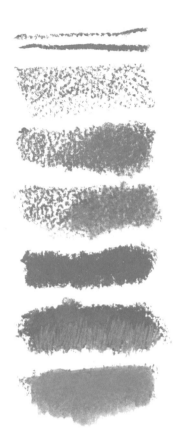

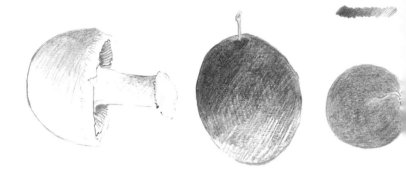

■ Illustration 37. After the initial exercises, try drawing some simple shapes like these. See if you can make them look three-dimensional through the way you vary or build up the medium.

■ Illustration 36. These experiments with oil pastel show lines, broken tone, overlaying colours, solid colour, scratching into colours and blending with a small piece of cloth dipped into a little turpentine.

Exercises

2. Now make one or two drawings of individual objects, like the fruit and vegetables shown in illustrations 37 and 38. Start with the outline shape and then look at the main areas of light and dark in your objects. Try drawing them in several different media to see what effects are possible and which media work best.

3. Take as your subject a view from a window. Draw this first in black and white, perhaps using charcoal or a fibre-tip pen, and then in colour, maybe in pastels or coloured pencils. Which drawing is the most successful? What are the main strengths and weaknesses of each medium?

■ Illustration 38. With a little confidence you can progress to a more resolved drawing. Try some studies like this one, using various media.

Lines and marks

From your initial experiments with various drawing tools and media you can now go on to check the scope of each one with regard to a number of basic drawing techniques. A knowledge of different techniques will mean that you can choose the most suitable method for your subject matter and the particular effects you wish to create.

First let's clarify what is meant by technique. In fact, the term is ambiguous in that it can relate to both the general use of a medium as well as specific methods of handling that medium. For example, charcoal drawing is a technique, as is using hatching, stippling or blending to apply the charcoal and create certain effects. Having already looked at the main drawing media in Chapter 2, now we will be concentrating on ways of applying these media. In the next three chapters we will be considering the principal techniques of line, tone and texture.

These techniques form the most significant part of learning to draw and so the next few chapters should be studied very carefully. Take your time to work through them, because it is vital that you practise every technique until you have some confidence with it. The illustrations will provide you with some useful examples to work from and there are additional suggestions, tips and words of advice in the captions. It is important that you try out the various techniques with as many different drawing materials as possible,

for this will give you a good range of basic skills from which to start developing your drawing ideas in a positive and individual way.

For most of these methods ordinary cartridge paper will be fine, but occasionally you might also like to try a heavier quality paper such as Ingres paper, sugar paper or watercolour paper. Don't worry about wasting time or paper. All the time spent on drawing and experimenting is helping to develop your skills and understanding of the subject. Keep all your try-outs, exercises and finished drawings for further reference.

Drawing with lines

Line is the most commonly used drawing technique and the most versatile. Most drawing tools are designed to make lines. So you can use lines to show the shape of something, to create light and dark areas and textures, and to suggest different surface effects,

like rippling water or windswept grass. Your lines can be delicate and sensitive or bold and expressive. They can be short or long, thick or thin, closely or widely spaced, curved, straight, ruled, freehand, and so on. A line drawing can be a quick sketch or a highly detailed study.

You may have explored the fundamentals of line in your experiments with various media in Chapter 2. If not, start by seeing what types of line are possible with each of your drawing tools and materials. Interesting ones to try are hard and soft pencils, charcoal and charcoal pencils, pastel, fine fibre-tip pens, a fine brush with some paint, and even an eraser. Remember that the way you hold and manipulate the medium will affect the sort of lines you create. For example, you will find that by varying the pressure on the drawing medium your lines will become thicker or thinner, lighter or darker. The type of paper you choose will also affect the sort of lines you can make. Try hatched lines, wavy lines, flowing lines, broken lines and so on.

You could add to these investigations by including some alternative methods of creating lines, for example by making an impressed line drawing. Do this by drawing on a sheet of paper with a spent ball-point pen or similar instrument so that the lines are indented into the surface and thus are not immediately visible. Now carefully shade over the whole area quite heavily with a soft (4B) pencil. By doing so the original marks should 'appear' as white lines against a dark background. As well as being an interesting technique in its own right, this effect can be used in heavily shaded or well-resolved pencil drawings to create 'accents' of light or to bring out particular details. Other possibilities include offsetting lines with the edge of a piece of card dipped in ink, and erasing lines from a sheet of paper that has been shaded over with soft pencil or charcoal, using the sharp point of a rubber, as in illustration 1.

Some more suggestions are shown in illustrations 37 to 39 and while these might be regarded purely as fun

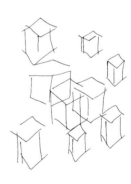

■ Illustration 39. Try drawing one or two simple shapes, like these cubes, with your eyes closed! This exercise helps you focus on the absolute essentials of a subject.

■ Illustration 40. To build up some confidence and control with the drawing tool or medium, another useful technique is to draw with a continuous line. *Pencil*.

ideas they are nevertheless entirely valid in helping to develop line techniques and confidence in handling different drawing tools. I can draw cubes better than those shown in illustration 39, but make allowances for the fact that I had my eyes closed for this drawing! Try it for yourself. This technique gives you good practice in visualising a shape in a very concentrated way as well as making positive lines in the right places.

Often drawings are more successful if you stick to a few self-imposed rules. Such 'rules' can give a unity and impact to the work, qualities which may prove lacking if the drawing is allowed to become complicated by involving too many ideas and techniques. So, when using lines, for example, keeping to a single type of line sometimes works best. Try doing a drawing, like the one shown in illustration 40, which is made up of a single, continuous line. This will test your imagination and ingenuity. Start at the top and do not remove your pen or pencil until the drawing is finished. You are allowed to backtrack over lines already drawn. Illustration 41 was made by holding a pencil and a fibre-tip pen together, creating a sort of double image effect. See if you can think of any other methods like these.

In a contour or outline drawing you can use the economy of line to great effect. By varying the thickness of line as well as its strength (light/dark value) you can achieve the impression of something three-dimensional. Thick bold lines will catch our attention, stand out and appear nearer, while weak, thin lines will give a sense of distance. There are many famous artists, including Picasso, Matisse, Klee and Hockney who have used this kind of line technique.

Contour drawing, as in the examples shown in illustrations 42 and 43, is a splendid technique for sketchbook work and preliminary studies. The essence of an idea can be captured in a few, well-chosen lines, using variations of emphasis to suggest some space and depth. Try drawing different objects in your room in this way, perhaps in charcoal and fibre pen, as well as pencil.

■ Illustration 41. This drawing was made with a pencil and fibre-tip pen held together – creating a kind of double-image effect.

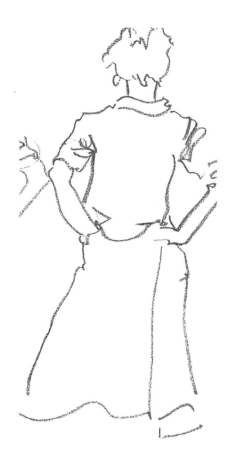

Surfaces can be modelled and different textures implied by using lines of various types and applying them with particular sensitivity and direction, perhaps involving more than one medium. Additionally, lines can suggest light and dark areas by varying their proximity. Note how, in illustration 44 (opposite), the heavier, closely-spaced lines help create dark shadows, while the weaker, more open lines suggest highlights and soft tones. In this drawing the line technique is totally effective, for it combines a sense of form and tone with something of the texture and characteristics of the subject. Other ways of using line to convey tone are explained in the next chapter.

■ Illustration 42. Contour drawing. Pastel.

Summary points

- Lines can be drawn with most drawing tools and materials.
- Use variations of pressure to create lines of different strength and intensity.
- Lines can suggest three-dimensional form, tone, textures and surface characteristics.
- Lines are good for outline drawings, sketchbook techniques, preliminary studies and composition roughs.
- You can combine lines with any other technique.

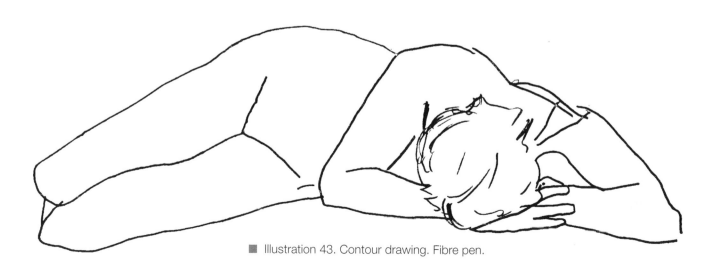

■ Illustration 43. Contour drawing. Fibre pen.

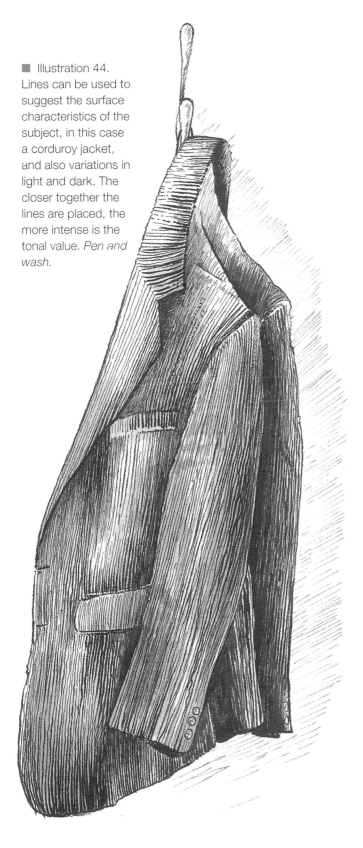

■ Illustration 44. Lines can be used to suggest the surface characteristics of the subject, in this case a corduroy jacket, and also variations in light and dark. The closer together the lines are placed, the more intense is the tonal value. *Pen and wash.*

Using guidelines

When we want to draw something very accurately it is usually a good idea to start with some faint guidelines to help us position things correctly and get the right shapes and sizes. The sequence of illustrations included in the next few pages shows how guidelines can be useful in establishing a basic structure for the drawing. They give us a sort of skeleton over which the accurate shapes can be evolved. To work in this way you must become accustomed to looking analytically and understanding which essential lines will provide the clues for the final drawing.

It can be argued that these construction lines, although aiding accuracy, give a rigidity and coldness to the work. Obviously this is a formal approach to drawing and worked as a step-by-step process it will hinder spontaneity and flow. However, there are many occasions in still-life compositions and general planning where a few quick guidelines can aid the way forward, with subsequent work developed as freely as you wish. Also, for beginners, it is sound practice to learn reliable ways of drawing cylindrical, symmetrical and similar basic shapes. Like perspective and other devices, once the theory of using guidelines is fully understood it will automatically influence the work without the necessity of going through all the stages.

Study illustrations 45 to 56 and try out some of these ideas for yourself. For the moment concentrate on leaning how to pick out the bare bones of a drawing, as well as practising the construction of ellipses, cylinders and symmetrical shapes in the way I have shown. Obviously this work is interrelated to perspective, a subject that is dealt with in detail in Chapter 7. You will also notice that guidelines feature in other drawings in this book.

Once you have mastered these basic shapes you can apply the same procedure to more complex objects. Box shapes are very much influenced by perspective, so I have considered these in that context in Chapter 7. Start by practising some curved lines, for example,

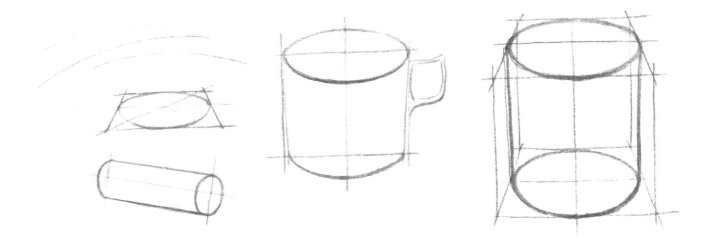

■ Illustration 45. Using guidelines to construct ellipses and cylindrical shapes.

as shown in illustration 45. Draw from inside the curve with a free-flowing action of the hand. If you are right-handed your curves will flow from left to right; if you are left-handed do the opposite. The action is from the wrist: try it with curves of different lengths and in different media. Think of an ellipse as a squashed circle. The degree to which it is squashed depends on your viewpoint: the higher your viewpoint, the more circular the ellipse.

Also in illustration 45, notice how an ellipse can be constructed using a grid of lines and that it fits into a square which is distorted according to our viewpoint. For this reason, the front half of the ellipse, being nearer to you, must be made slightly bigger than the back half.

Cylinders and similar shapes can be based on a rectangle constructed to fit the estimated proportions of width to height. Central guidelines are used to help ensure that the shape is balanced and to plot out the ellipses. For a shape like a cup start by constructing the main cylinder (the body) and then add other parts, such as the handle, to this. A common fault is to 'point' the ellipses at each side. Remember that it is

easier and more natural to draw from inside the curve, so turn your paper upside down to draw the nearer half of the ellipse. Think of it as a continuous line – no points or corners.

For a cylinder or tube which is lying on its side fix the centre lines, as shown in the illustration, and note that the foundation rectangular shape is distorted by perspective as it recedes. These centre lines are also known as 'axis lines', particularly when they show the angle and direction of the basic shape, as here.

Many shapes are symmetrical, that is, equally balanced, or they are basically symmetrical with something added, like a handle. Once again, such shapes can be plotted either side of a central guideline. Begin with a rectangle based on the maximum width and height. Put in a central line and draw one side of the shape. Notice where the shape changes direction and estimate such points in proportion to the whole. If you are right-handed, you will find it easier to draw the left-hand half of the shape first, and if you are left-handed, vice versa. When you are satisfied with this, draw some guidelines across at key points where the outline alters. You can mark off a point on these lines

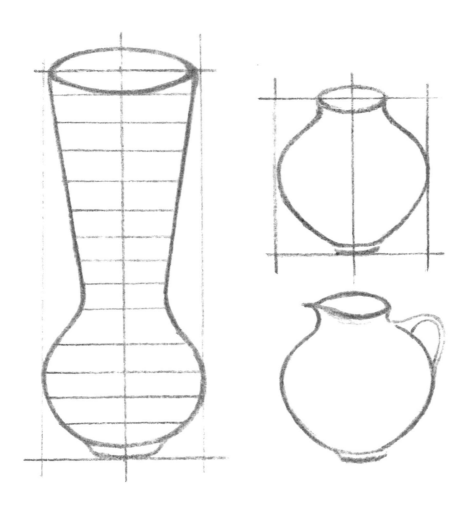

■ Illustration 46. Using guidelines for symmetrical shapes.

which is the same distance from the centre as the corresponding point on the opposite side. Like the drawing in illustration 46, create a series of these points which you can then join up to establish the other half of the shape. Rub out the unwanted faint guidelines and modify the main shape as necessary. Now practise all of the shapes in illustrations 45 and 46 for yourself.

For other objects use as many or as few guidelines as seem necessary to help you build up an accurate outline (see illustrations 47–51). From the basic framework you can get a good outline drawing and then add detail and tone or colour.

Initial guidelines are especially helpful when planning a composition like the one shown in illustration 52. Here you need to fix the overall scale of the work before defining the position and shape of each object and its overall size relative to the others. Guidelines are helpful for checking angles and proportions when drawing any subject and they are particularly useful when drawing the human figure, as demonstrated in illustrations 54, 55 and 56.

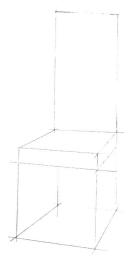

1 Illustration 47. Chair, stage 1: Start with some guidelines to fix the main shapes and angles.

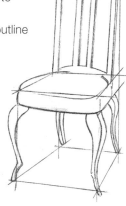

2 Illustration 48. Chair, stage 2: use the guidelines to make an accurate outline drawing.

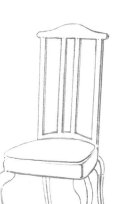

3 Illustration 49. Chair, stage 3: rub out the guidelines and perfect the outlines.

4 Illustration 50. Chair, stage 4: look at the object through half-closed eyes and notice the distribution of lights and darks. Add appropriate shading.

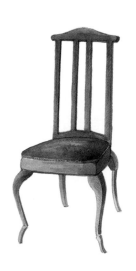

5 Illustration 51. Chair, stage 5: alternatively you could colour the drawing, perhaps with light watercolour washes, as here.

■ Illustration 52. Initial guidelines are particularly helpful when planning a more complex composition, both to help position the whole group on the sheet of paper and to fix the position of individual shapes in relation to each other.

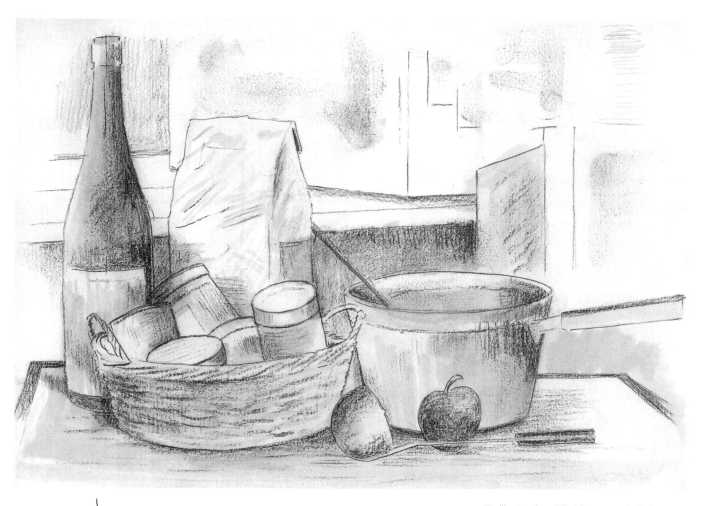

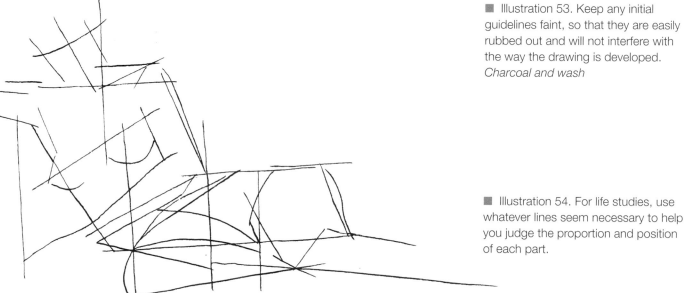

■ Illustration 53. Keep any initial guidelines faint, so that they are easily rubbed out and will not interfere with the way the drawing is developed. *Charcoal and wash*

■ Illustration 54. For life studies, use whatever lines seem necessary to help you judge the proportion and position of each part.

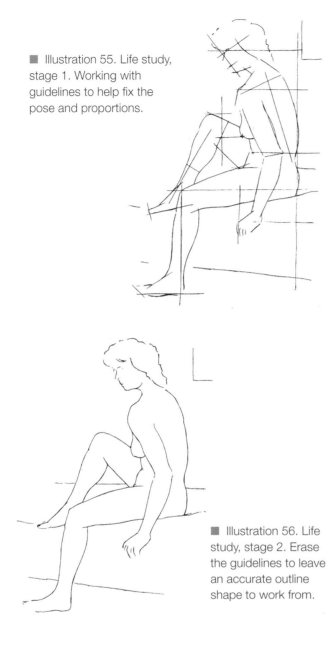

■ Illustration 55. Life study, stage 1. Working with guidelines to help fix the pose and proportions.

■ Illustration 56. Life study, stage 2. Erase the guidelines to leave an accurate outline shape to work from.

Use guidelines for:

■ plotting particular shapes and measurements, especially symmetrical shapes;
■ checking the position of one thing in relation to another;
■ planning overall scale and composition.

Negative shapes

As well as using guidelines in the manner described, something else which can help in constructing accurate shapes is to look at the background areas or 'negative' spaces around them. The gaps in and around the subject you are drawing will often help in observing and understanding it. So, as a further check when you are drawing a particular object, refer to the spaces around it to help you define it more clearly.

Drawing with point

Lines are one way of making marks. Another good method is to use dots or 'stabs' of tone or colour.

Soft pencils and most pens are suitable for this technique, especially fine, fibre-tipped pens, ball-point pens, art pens, and technical pens which use interchangeable nibs of various thicknesses. Use the instrument vertically and pounce it up and down to produce dots, or hold it at a slight angle if you want to achieve little stabs of tone. Usually it is possible to create slight variations of light and dark by varying the pressure. Also, of course, you can combine different drawing tools, although it is best to do a few tests first to check their compatibility. Some pens use a much more intense ink than others. Equally, exciting drawings are possible by using a range of coloured pencils, the softer conté pencils generally proving the most suitable. Your experiments with this technique might also reveal that you can make dots and dashes by other means: offsetting from a drinking straw, a thin piece of dowel or the blunt end of a paintbrush dipped in ink, for example.

It has to be said that making a drawing entirely with dots can be a time-consuming and somewhat repetitive process. On the other hand, the broken texture and tone effects are unusual and visually very interesting. This is a method which is particularly good for exploring subtle variations of light and dark, as in my

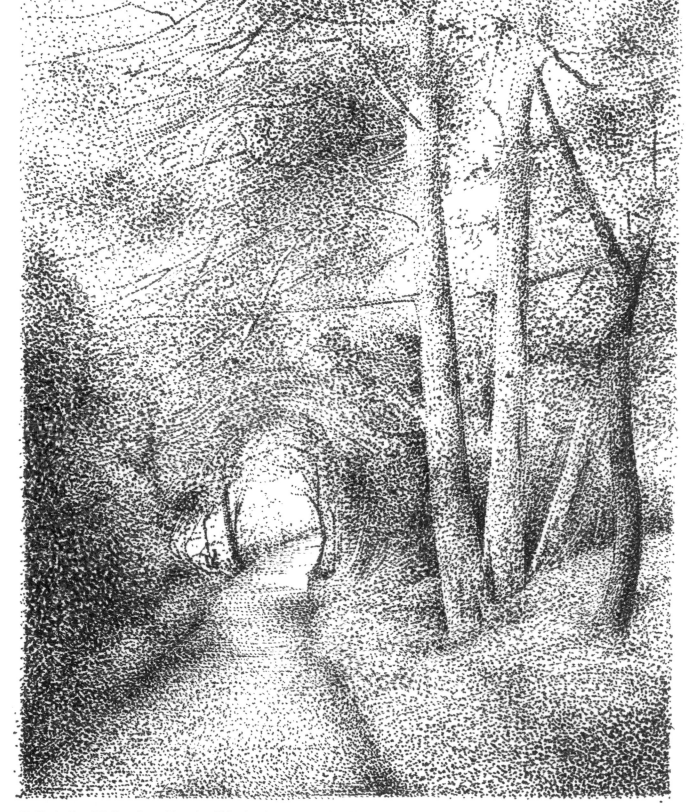

■ Illustration 57. Drawing with point. This drawing was made with a fine fibre-tip pen, holding it vertically and bouncing it up and down to produce a sequence of dots. By varying the pressure on the pen and the spacing of the dots you can create contrasts of light and dark areas.

woodland study in illustration 57. Here I used a fine fibre-tip pen exploiting different pressures and spacing to vary the intensity of the tones. Like many of the 'pointillist' drawings by Van Gogh, Signac and Seurat, point combines well with linear and other techniques.

Point techniques should be chosen to suit a particular purpose in your drawing, and you may have to combine several different techniques to achieve the effects you want. They are often best for suggesting an uneven or textured surface, faint outlines, or light to dark shadows. Outlines formed from a series of dots are less rigid and precise than those made as a continuous, solid line, making the mood or feeling of the drawing softer and freer. When deciding which point technique to use, think of the effect you want to suggest and try to match it up with one of the methods listed below. Remember that you will need to choose a type of paper to suit the media and techniques you have in mind.

Here are some ideas:

- **Pencils.** Various types of pencil are suitable, but softer pencils such as 4B and 6B will give the most successful results. Charcoal pencils are also useful. Vary the pressure on a soft pencil to give contrasting light and dark effects.
- **Pens.** Use fibre-tip, ball-point or technical pens. You can combine the use of a fine and a thicker pen to give more scope to your work. Don't press too hard or you will damage the nib or point of the pen.
- **Dowel.** You can make larger dots by dipping the end of a round pencil into some ink and pressing this down onto your drawing. This method is known as offsetting and it can be used to create pattern effects in your drawing or large areas of heavy texture. You can cut short lengths of round wood or dowel especially for this purpose. Used in the same way, drinking straws will give an open texture which can be very interesting and effective.
- **Stipple.** Use a stiff-haired round hog brush or a special stippling brush for this technique. Dip the brush into some ink or paint and offset it by

stabbing it up and down on your paper. Use just a little ink or paint on the brush.
- **Spray and spatter.** Sprayed areas make good backgrounds and textures and combine well with pen and ink drawing. Use a spray diffuser with some drawing ink or alternatively try using an old toothbrush dipped into some ink or paint. Hold the brush directly in front of the part of the drawing you want to spatter and pull back the bristles with your forefinger. As the bristles spring back they will shower the drawing with fine spray. If you want to keep the spatter to a limited area then you will need to cover the rest of the drawing with some scrap sheets of paper. Spray effects are dealt with in more detail in Chapter 5.

Exercises

1. Make an outline drawing of a telephone, an upright chair, and a bunch of keys. Choose a different medium for each drawing.
2. Assemble a still life group consisting of four or five kitchen objects. Select them carefully to give a variety of shapes and sizes and arrange them into an interesting composition. Refer to illustrations 52 and 53 and make a line drawing on an A2 sheet of paper which plots the accurate shape and position of each object.
3. Make some experiments in your sketchbook using a variety of drawing tools to produce a range of point effects, from very small and faint dots to large and bold ones. Try coloured pencils and pastels as well as ordinary pencils and pens.
4. Study the method used in illustration 57 and make a drawing of a lace-up shoe, using point techniques to convey its shape and form.

Working with tone

In most of your drawings you will want to convey a good likeness of something and, to achieve that, usually one of the main problems will be how to make things look three-dimensional. As drawings are made on a flat, two-dimensional sheet of paper, artists have to employ various devices to create the illusion of space and depth. Working with tone is one way of doing this.

Tone, which is the use of light and dark in a drawing, will help you give the impression of substance and form, space and distance. To understand tone you must first learn to notice and appreciate the way light plays on different objects, creating a whole range of effects from deep, dark shadows to glinting highlights. This distribution of light and dark helps to describe the form of the object and consequently

■ Illustration 58. A tonal strip. Make one of these to help you assess the strength and variety of tones in the different subjects you want to draw. Use a 3B or 4B pencil and, starting with light pressure, gradate the tone from very light to very dark, as shown. Hold the strip up to the subject you are drawing and match each part to its corresponding tone on the strip.

makes it look curved, undulating, square and so on.

You will need to develop a variety of shading techniques so that you can apply a range of tonal effects from light to dark in your drawings. Each drawing medium or tool will produce its own range of tone and certain tonal characteristics. In some, like felt-pens, the degree of variation is limited, while in others, like charcoal or soft pencil, there can be an extensive range from subtle lights to intense darks. With most media, variations of tone are achieved by altering the pressure applied. Get used to handling different media in this way so that you know what tonal effects they can give. In some of your drawings you might need to combine several drawing tools or media in order to create the right contrasts in tone and surface characteristics. When you are drawing in pencil, for example, you will probably have to use several different degrees of pencil (perhaps a 4B, 2B and HB) in order to achieve a good range of tones.

Test out various media and shading techniques in the way demonstrated in illustrations 58 and 59. Try the

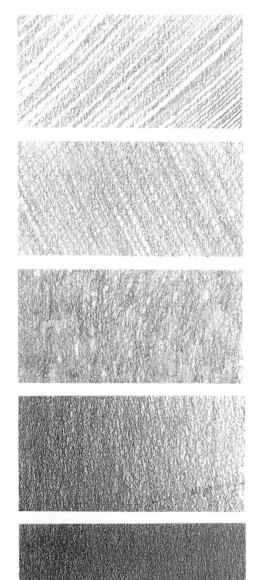

same sequence of exercises, then see if you can find other methods, perhaps using different media. As always, remember that the type of paper is important: use cartridge paper for pencil work, a smooth art paper for fine pens, and sugar paper or a heavier quality paper (Ingres, watercolour, etc.) for charcoal. Your exercises could include the following techniques:

- **Hatching.** Use short, crisp lines at an angle of about 45°. Notice how the spacing and strength of the lines determines the intensity of the tone.
- **Cross-hatching.** Work as for hatching then cover with a series of lines in the opposite direction. This creates a more solid tone effect.
- **Linear tone.** You can shade with a series of straight lines. The spacing and strength of the lines is important. Use thin, faint lines for suggesting a light area of tone and thicker, darker lines for a heavy tone.
- **Pressure.** Use a soft pencil (3B–6B). Hold the pencil almost horizontally so that the side of the lead is used. Start with very heavy pressure and gradually reduce this so that your shading goes from very dark to light. Try to achieve this without any obvious gaps or lines.
- **Blended.** You can use a soft pencil, charcoal or pastel for this technique. For a subtle effect, work the tone into the surface of the paper by gently smudging it with your finger or a small piece of paper or cloth.
- **Shading and erasing.** For highlights, like the reflections on glass or water, shade all over the area first and then rub out lines and patches with a clean, pointed piece of rubber. If necessary cut a thin slice from an eraser to use for this purpose. Putty rubbers and other soft erasers can also be used for blending. Eraser techniques are covered in more detail on page 46.
- **Charcoal.** For small areas, hold and use the charcoal like a pencil. For bigger areas, use a short length of charcoal on its side. Do not press too hard or the charcoal will shatter! You can blend charcoal in the manner described above.

■ Illustration 59. Various ways of creating tone with a soft pencil: hatching; cross-hatching; using the lead of the pencil on its side to create an even tone; varying the pressure to make a dark to light effect; creating a smooth, even tone by rubbing the pencil into the surface of the paper with a small piece of paper; and using an eraser to lift out highlights.

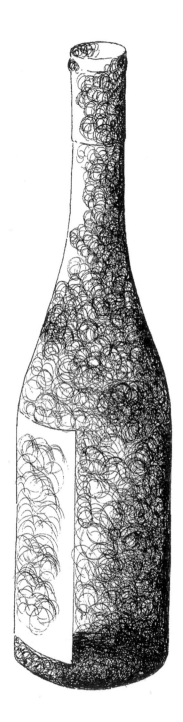

■ **Pen**. Fine pens will suit line techniques such as hatching, point and other ideas, like the circular, almost scribbled tone effect shown in illustration 60.

Light and shadows

When you are drawing from direct observation begin by making a careful assessment of the source and direction of light, and consequently the extent and distribution of shadows and the general tonal 'key' of the subject. It could be that your subject is evenly lit and therefore there are few darks of any significance. Alternatively, a strong light from a particular direction will cause positive shadows and perhaps many variations of tone. Draw a simple object to try out these differences. See illustration 61.

■ Illustration 60. You can use all sorts of methods to suggest variations of tone. Note the scribbling technique used here, made with a fine fibre-tip pen.

■ Illustration 61. In all your drawings it is important to note the source and direction of light. This will help you to understand the different tonal values involved and to place the shadows.

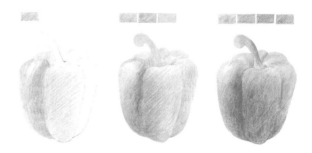

■ Illustration 64. You also need to think about tone when you are using colour. Consider the lightest areas first and then gradually build up the darks by working one colour over another.

■ Illustration 62. Use the white of the paper as the lightest tone and to begin with think in terms of three main tones: dark, medium and light.

■ Illustration 63. In this charcoal pencil drawing, the darker tones have been implied by using the hatched lines closer together and increasing the pressure on the pencil.

Tone, like many aspects of drawing, will generally work best if it is simplified. If you half close your eyes it will help you identify the main light and dark areas. To begin with, think in terms of three main tones: dark, medium, and light. Avoid overshading. In general, use

the white of the paper as the lightest tone and try to achieve some good contrasts between this and the darkest areas. Now make a drawing which restricts tone in this way, like the still life in illustration 62.

Short, hatched strokes were used in illustration 63, using a charcoal pencil with variations of pressure to help achieve different tones. The step-by-step demonstration in illustration 64 above was drawn with soft, coloured pencils, varying the pressure as necessary and keeping the pencils really sharp for the more defined lines.

Tone and shape work together to give us a real likeness of something. Sometimes the shape is confused by the great range of light and textures which adorn it. So think in terms of shape first before tackling the modelling and detail. The drawings in illustrations 65 and 66 combine various pencil shading methods: solid tone, variations of pressure, blended tone and erased highlights. Now compare illustrations 67 and 68. Note how, when you draw in colour, you must also think of light and dark values.

Erasers and tone

Obviously erasers are useful as a means of correcting mistakes in a drawing, but equally they can be used

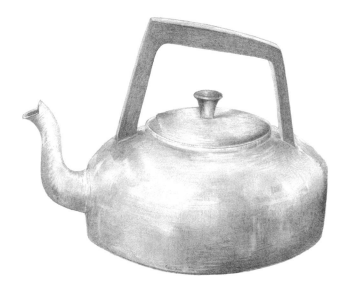

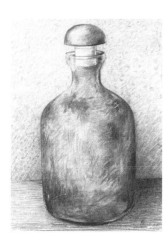

■ Illustration 66. A careful study of the lights and darks will help you create a three-dimensional effect, but try not to overshade areas.

■ Illustration 65. With experience you can start to combine a number of the tone techniques shown in illustration 60. Note how most of the highlights in this drawing have been lifted out with an eraser.

much more creatively, especially when you are working with tone. With the right eraser and technique you can quickly add to the interest, vitality, movement, atmosphere and other qualities involved in interpreting an idea. Indeed, whatever the circumstances and approach, it is far better to view erasers as contributing positively to the development of a work, rather than seeing them only in a negative context – simply as a way of eradicating a mistake.

Of course it may well be necessary to use a vigorous rubbing action to erase part of a drawing completely, but on other occasions a soft dabbing technique might be all that is required to weaken a tone or fade an outline. The sharp corner of an eraser can be used to

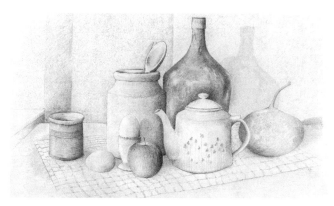

■ Illustration 67. Tonal study: Graphite pencils

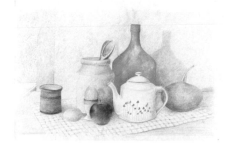

■ Illustration 68. Tonal study: Coloured pencils. Note the various techniques used in both this and the previous drawing to suggest different tonal and textural qualities.

lift out a small accent or highlight from a dark tone while, worked against a straight-edge, an eraser will help create a really crisp edge or outline to selected tonal areas. In contrast to a conventional drawing, where the strongest tones are built up gradually while preserving the light areas, by placing more emphasis on the use of the eraser you can work the other way round. Try beginning with the dark tones and then using a soft eraser to take out the lightest parts.

The smaller wedge-shaped rubbers are very useful for working into an area of tone or colour to create flecks of light, small highlights, or slightly softer, contrasting passages. Held quite vertically and using just the sharp edge of the wedge-shape, this type of eraser is ideal for adding accents of light to water, for example. Swiftly pull the eraser in a horizontal direction to lift out fine lines. Another advantage of the wedge-shaped edge is that it allows you to 'draw' with the eraser and tidy-up and lift out quite precisely up to a clearly defined outline. Alternatively, you can use the whole width of the eraser, lightly dragging it across an area to soften the tone.

See page 26 for information on the different types of erasers and look again at illustrations 1, 65 and 66. Here are some tips for using erasers:

- Keep your eraser clean by occasionally rubbing it on some scrap paper to offset any accumulated graphite dust and similar deposits. With a plastic or India-rubber eraser, if it gets really dirty you can trim back the edge with a craft knife.
- To make really fine 'negative' lines and highlights, break off a small piece from a putty eraser or cut a small sliver from an India-rubber or plastic eraser.
- When you modify a dark tone in one area the eraser will pick up a certain amount of medium and you can take advantage of this by dabbing the eraser up and down or dragging it across another part of the drawing where you require a light tone or texture.

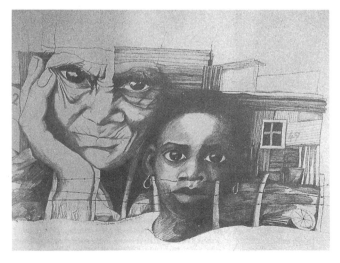

■ Illustration 69. Very dark values were contrasted with bright highlights to create the faces in this expressive drawing titled *In Skietaan*, by the artist Petra Rohr-Roendahl.

Exercises

Ensure that you have completed the various exercises mentioned in the text.
1. Make two tonal studies of part of a garden, park or landscape. Begin by half-closing your eyes to help you assess the various tones involved, and refer to the tonal strip shown in illustration 58. Make the first sketch in soft pencil, charcoal or charcoal pencils and the second sketch in coloured pencils, aiming to relate colour to tone, that is paying particular attention to light and dark values.
2. Make a pencil drawing of a basket and some items of shopping from a supermarket. Concentrate on constructing accurate shapes and suggesting the three-dimensional form of each object through the use of tone. Ignore details such as lettering, patterns and decorative designs.

Texture and other techniques

Look around and you will see that many subjects involve texture – that is a particular surface quality. Some things are completely smooth while others are grained, rippled, woven, indented, furry and so on. A cobbled path is an obvious example of this.

If you want your drawing to be truly representational then, as well as a concern for the form, tone and colour of the various elements that make up the subject, you will also need to show the different surface textures involved. However, although most drawing media can be handled so as to imply texture, a drawing cannot create actual relief and tactile qualities in the same way that, for example, an oil painting can. So you have to employ techniques that give the impression of texture.

There are various ways of suggesting texture and you may have already discovered some of these through your experiments with different media. Drawing in line and point will have shown that short, hatched lines and cross-hatched lines will convey a form of texture, as will a dotting technique. Other methods could include spraying, spattering, stippling and offsetting. And dragging the side of a stick of charcoal, conté crayon or pastel across a sheet of heavy quality paper will also give interesting effects.

By experimenting and gaining some experience with all of these methods you should be able to decide how

best to interpret a particular surface. But whichever technique you choose, you must ensure that it is compatible with the rest of the drawing and that it suits the type of paper being used. Working on 300 gsm watercolour paper with pastel or charcoal, for example, is a good way to create an overall feeling of texture, but the disadvantage here is that, because of the coarse surface, it will be difficult to make really smooth areas. So, to achieve a wide range of effects, you will probably have to arrive at a compromise in the type of paper you choose and the mixture of techniques you employ. If you have any doubts about the suitability of the paper you intend using for a subject that involves different textures, then do a small test exercise first on an offcut of the same type of paper.

Get a feeling for textures by trying out the techniques listed below:

- **Rubbings.** Work on thin drawing paper. Place it on a textured surface, like woodgrain, a metal grille or frosted glass and, using a short length of wax crayon on its side, shade over the particular shape

■ Illustration 70. Creating different texture effects: sponge; stipple; spattering; and wax resist.

or area required. Apply only light pressure to the crayon. You can build up the necessary strength of tone by shading across the area several times.

■ **Sponge.** For a mottled texture, dip a small piece of natural or synthetic sponge into some diluted ink or paint and lightly press it down on the paper. Check that there is only a light coating of ink or paint on the sponge, otherwise you will create a solid tone rather than a broken texture. Test the effect on a sheet of scrap paper before applying the sponge to the actual drawing. Small artists' sponges, as used in watercolour painting, are available from most art material shops.

■ **Stipple.** Use an old stiff-haired brush and dip this in a very shallow quantity of paint or ink. With just a little medium on the brush, and holding it vertically, dab it up and down to produce a broken, speckled texture effect.

■ **Spattering.** Make a fine spray by dipping an old toothbrush or a hog-hair paint brush into some ink or paint. Prop up the paper so that it is almost vertical. Holding the brush a little distance from the paper, pull back the bristles with your forefinger to release the spray.

■ **Dry brush.** Work on rough-surfaced paper. Use a stiff-haired brush that is lightly laden with some

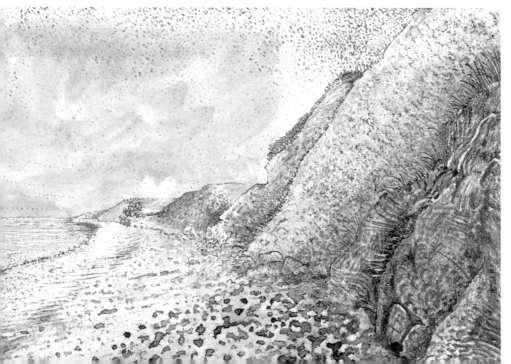

■ Illustration 71. For some subjects you will need to use a variety of texture effects. This drawing includes a dotted texture made with a pencil for the clouds, dashed pencil lines for the sea, wax resist for the beach and stippling and soft pencil techniques for the cliffs.

ink or paint and drag this across the paper so that it just catches the 'tooth' or high parts of the surface. This is a good technique for suggesting water.
■ **Resist.** Coat the paper with a thin layer of wax crayon, or use a candle. Paint over this with watercolour or diluted ink to create a random blotchy texture.

All of these methods can be developed further, perhaps to create stronger tones or combine other colours and effects, by repeating the same process or introducing another technique. Although you might use such methods only very occasionally, they can add much more interest and impact to a drawing. Study the illustrations in this chapter, and the information in the captions, to see some of the possibilities.

Line and wash

Wash is thinned down ink or paint. You can make a wash by putting a very small amount of ink or paint in a shallow container or palette and mixing it with plenty of water. Add as much water as you need in order to get the required tone or colour. For use in a tonal drawing, that is one made with graphite pencils, charcoal or black ink, make the wash with one or two drops of Indian ink, while for a coloured drawing use coloured inks or watercolours. Test out the wash on some scrap paper first, before applying it to your drawing.

Wash is normally applied sparingly with a large, soft brush to tint areas of a line drawing, like the pen and wash study shown in illustration 72. You can use various strengths or colours, or work over parts with several layers of wash until the correct strength is obtained. Work on good quality cartridge paper, preferably sheets that have been stretched. Your main drawing can be in almost any medium, but bear in mind that most felt-tip and fibre-tip pens as well as soft media, like charcoal and pastel, are not permanent. This means that they will fuzz or bleed if wetted with the wash, although that can be an

■ Illustration 72. A simple pen and wash study. *Mapping pen, Indian ink and watercolour washes.*

■ Illustration 73. Working with pencil and wash. This is a good technique for sketchbook studies. Draw the main shapes and lines in pencil and then add a few thin watercolour washes to indicate the colours.

advantage if loose, atmospheric effects are required. Pencil and Indian ink lines are more permanent.

You can also use a wash technique for general background effects, perhaps tinting the whole sheet of paper prior to drawing. In this case use a very large flat brush, working from top to bottom and from side to side. In addition, you can use wash over a resist

medium such as wax or masking fluid. Brushed over wax, the wash will produce an interesting mottled texture, while masking fluid is useful for blocking out specific shapes and details. With large areas of wash you must work quickly to avoid any premature drying and the consequent uneven patches. Use the largest brush possible.

Here are some other ideas for wash effects:

■ **Uneven wash.** Have several colours ready and a brush for each one. Start at the top and work down, brushing in the appropriate colour as you go. You may want to let colours run or merge into each other to give a particular effect, such as for a sky.

- **Gradated wash.** Mix three separate tones of the same colour wash: light, medium, and dark. Use a different brush for each tone. Work from light to dark, brushing in a strip of each tone. Let them almost dry and then blend the tones together by working over them from top to bottom with a large, soft brush which has been dipped in clean water. Alternatively, apply the wash to damp paper.
- **Brush drawing.** Experiment with several types of brushes. Use variations of pressure on the brush, different strengths of ink or paint, and different kinds of paper.
- **Brush and wet paper.** Use damp or wet paper if you want the brush lines to appear blurred. You can use this technique for making effects like the surface of water.

■ Illustration 75. This drawing was made on watercolour paper to suit the various ink and wash techniques that were used. Note the texture for the ground area. This was made with a hog hair brush dipped in just a little paint, so that when it was dragged across the paper it just caught the surface, creating a broken, 'dry-brush' texture.

■ Illustration 74. For a wash drawing like this, start with the light areas and, where required, work over these with further washes to create the darks.

Robin Capon

■ Illustration 76. The different techniques used here include stippling, wash, and spattering in the foreground.

Spray techniques

Ink and thin paint can also be sprayed or spattered on to a drawing and will create the sort of effect shown in the foreground area of illustration 76 which, incidentally, also includes some brush and wash techniques. For this drawing I used the spattering method, as described on page 50, although similar effects can be achieved with an airbrush or by using a metal spray diffuser with some Indian ink. While an airbrush is far more reliable and controllable, it is nevertheless an expensive item of equipment and so is not worth purchasing unless required frequently.

With diffuser and airbrush techniques you will need to mask out certain parts of the drawing to prevent them receiving any spray, and cover the immediate vicinity with newspapers for the same reason! Small details can be blocked out with masking fluid, otherwise use specific shapes cut from paper and fixed to the drawing with Blu-Tack. When you have sketched in your composition, make a tracing of those parts which must not be sprayed. Transfer the traced out shapes on to thin paper, then cut them out and fix them to the drawing in the manner already described. Make some test sprays first. Tilt the drawing at a slight angle, then spray in light coatings, building up the intensity of the tone or colour you require. The further back from the drawing you stand, the finer will be the spray.

Using mixed media

Having now tried out the techniques of line, point, tone and texture with different drawing tools and materials you will begin to realise the potential for combining media. Often a single medium is most effective and will be ideal for a particular subject. However, as you have seen with tone and texture, occasionally it is necessary to combine several media within the same drawing in order to get the most convincing result. Additionally, mixed media effects will give lively contrasts and add to the interest of the drawing.

So, don't be afraid to experiment with a combination of drawing tools and materials in order to increase the scope of your drawing and interpret surfaces in the best way. Remember to check the suitability of your drawing paper to the range of media you intend using. If you have doubts about individual media or techniques, test them out on some scrap paper before using them in the actual drawing. You might include some media specifically because they allow you to draw in detail, while others give you the textures and tones you want or add to the general vitality and atmosphere of the drawing. See illustration 77.

Try these ideas:

- A drawing using a range of hard to soft graphite pencils.
- A pencil drawing with added washes of colour.
- An Indian ink drawing with colour washes of watercolour.
- A brush drawing developed with charcoal.
- A tonal study using soft pencil, charcoal and charcoal pencil.

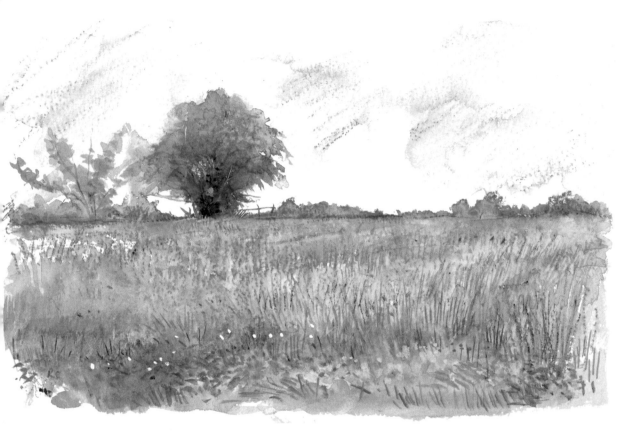

■ Illustration 77. Sometimes, the best way to interpret a subject is to use a combination of different media. Wash, wax crayon, pastel and coloured pencil techniques have all been used in this drawing.

Matching medium to method

It follows that the choice of medium must suit the techniques you have decided to use in your drawing. You would not choose to make a fine line drawing with a thick stick of charcoal, for example, just as you would not expect great delicacy of tone from a felt marker pen. Medium and technique are interlinked. As you gain experience with different drawing materials you will get to know their individual capabilities and characteristics and the range of techniques and effects they allow. Equally, experience will help you judge at the outset of a drawing which media to choose to give you the interpretation and impact you want.

Exercises

1. Make a careful drawing of a textured piece of bark or heavily grained wood.
2. Find an interesting old building in your locality and make several studies in your sketchbook. Like illustration 73, use a pencil and wash or pen and wash technique for your drawings.
3. Try one or two experiments with spatter, stippling and spray techniques and then incorporate one of these methods into a drawing of a subject of your choice. If you need some ideas, have another look through the various illustrations you have seen so far in this book.

Looking, seeing and interpreting

Quite likely, most of your drawings will be made from direct observation. This means that normally you will be drawing with the actual subject matter immediately in front of you, whether this is something you have deliberately chosen or arranged at home, or a landscape view or other scene that you have found outdoors.

Usually you will want to create a drawing *of* the subject, and in this case realism and accuracy will be important considerations. On other occasions you may decide to draw *from* the subject, which will allow you to be more selective and original in your approach. However, before starting any drawings you will need to make various decisions. For instance, having chosen what to draw, you will need to decide how large the drawing is going to be, which medium and techniques will work best, and what sort of drawing you want. So, for each drawing you will set out with certain intentions. As the work progresses you may, of course, decide to change these intentions, and at the end you can judge just how far you have succeeded in realising your aims and objectives.

To begin with it is wise to investigate different media, practise the basic techniques and do a lot of carefully observed drawings of a wide variety of subjects. Later, as your own style and ideas about drawing emerge, you will want to draw in a more subjective and personal way. But even those who draw from memory and imagination need the initial discipline of observation and the accumulation of an accurate and extensive visual vocabulary of different shapes and subjects.

But, drawing is much more than acquiring skill with the hand. Equally, it requires looking, perceiving and the desire to communicate ideas in a visual way. Confronted with the problem of translating the subject matter before us into a convincing drawing, we must first look and understand. An important part of learning to draw is therefore learning to look and notice things. Success does not rely solely on our ability to handle a particular technique. It also depends on the keen observation of proportions, structure, form, detail, characteristics, and so on. Thus, artists need to be constantly alert and enquiring!

Consequently you will appreciate that even before you can commit any marks to paper, drawing is already a matter of asking questions and reaching decisions. And there are no short cuts. A casual glance at something will merely give you a limited reference to work from.

Instead, get used to looking at everything in a questioning way in order to provide yourself with plenty of information, and examine each new idea with a fresh eye, even if it is a shape or subject that you think you know well. Try to avoid general assumptions or preconceptions about the subject and, as you consider ideas, compositions and the progress of the drawing, remember to treat each part in relation to the whole.

To help yourself look at things carefully you should do as much drawing as possible. This is one reason why you should keep a sketchbook, and there is more information on this in Chapter 8. You will find that if you are really interested and excited by a subject you are more likely to achieve a good drawing. Attitude and enthusiasm are other important factors influencing your success. Equally, you will need to practise and persevere. Of course, you will not like everything you do, but quite often you will find that even in your weakest drawings there are some elements of success. By all means be self-critical, for this will aid your progress, but don't take too much notice of those people who assume that a drawing is poor if it doesn't look virtually photographic – there is no single correct way to draw!

Throughout this book there is an underlying emphasis on looking and seeing. I have stressed the importance of looking in a way which helps you understand the subject so that you can then draw it more accurately. I should not, however, like to give the impression that understanding can only lead to straightforward observation studies. But because such drawings help train the eye as well as the hand, they are ideal for the beginner. As you learn more about drawing you will discover that it can also be concerned with expressing your feelings. From the same basis of understanding what you see you can interpret things in your own personal way, perhaps by emphasising certain points or analysing, selecting and developing particular aspects. Now let's look at these various approaches in more detail. Bear in mind that a drawing which concentrates on one of these approaches need not necessarily preclude all the others.

Observation

In many ways drawing and painting are inseparable. Each can be regarded as a distinct discipline in its own right, though it is difficult to define rigid boundaries. Creating a painting often involves a lot of preliminary drawing, just as making a drawing sometimes includes brush and paint techniques. In the past drawings were considered mainly as essential preparatory work for painting rather than as separate works of art. Most drawings were made as studies, for information and research, or as composition roughs and cartoons. Although the scope and importance of drawing has developed, its original role remains vital. Whether they are employed in preparatory work, in the evolution of designs, or in presenting information, drawing skills are essential to all artists, designers and craftspeople. For many, there is still a need to make carefully observed drawings from life.

When we set out to make an accurate likeness of an object or scene before us this is known as working from direct observation. In such drawings we are working objectively, aiming for a true representation without any elaboration, emphasis or selectivity. We need to be inquisitive; the importance of looking, noticing and understanding has already been stressed.

Before you start some observation drawings of your own think about these points:

- The selection and arrangement of the different shapes or objects involved and how these can be used to make an interesting composition.
- The relative size and position of individual shapes and their structure: how are the shapes formed?
- Light and dark values: tonal qualities.
- Colour, and surface textures and details.
- The sort of effects you want and therefore the most suitable drawing medium (or media) and type of paper.

Consider these points in relation to illustrations 78 and 79. The first step in any drawing is roughly to plan

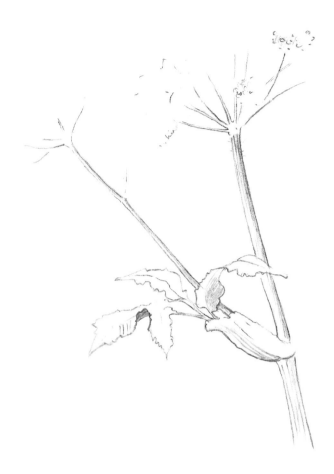

■ Illustration 78. Observation study, stage 1. Considering the basic structure and main forms of the subject.

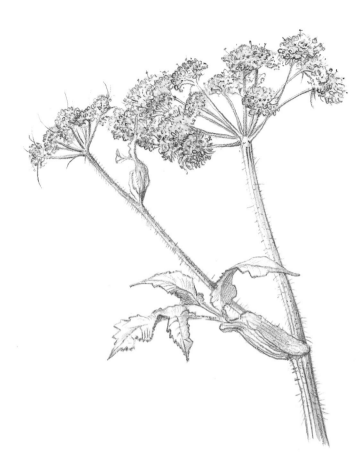

■ Illustration 79. Observation study, stage 2. Adding tone and detail.

it out so as to fit the paper and such that the main shapes are in the correct positions and proportions. Getting a good 'structure' to the drawing is important, so that you can then develop it with confidence. Look at illustration 78 and note how the structure has been sketched in and the drawing is gradually being worked over with more detail and accuracy. Compare this to the completed pencil drawing in illustration 79 in which various techniques have been used to show different tonal effects, textures and surface details.

Analysis

Observation may, of course, include a certain amount of analysis but it is usually concerned with making a single drawing from a single viewpoint. Sometimes we need more than this and want to examine the subject in greater detail. In such cases a whole series of drawings might be necessary. These could show different viewpoints as well as consider all the factors listed for observation drawings. Alternatively, several

RC
1·1·94

■ Illustration 80. Where a subject offers a number of interesting qualities, try making several drawings, focusing on a different quality in each one.

drawings could be made from the same viewpoint but with each drawing focusing on a different aspect: form, colour, texture, detail and so on. Such an approach will probably require a variety of media and techniques.

Demanding detailed enquiry and entailing a range of drawing skills, analytical drawings therefore provide sound practice for the beginner – indeed, for any artist. Occasionally, it is a good idea to really probe a subject in this way, and such drawings will provide valuable preparatory information and research for more elaborate or imaginative works.

Natural forms make ideal subject matter for analytical drawings. They can be twisted and examined from various angles and often have interesting colours, details and textures to deal with. Sometimes, like the fish studies in illustration 80, they can be cut open and drawn in sectional view as well. With more complex subjects, another possibility is to make a line drawing of the complete shape and then isolate a section for particular analysis, as in illustration 81.

Selection

Observation and analysis are objective approaches which lead to informative, representational drawings. While these processes are the basis of most of our work, they are not always an end in themselves. As we gain in confidence and skill we may wish to impose a certain personal interpretation on what we see.

None of us sees a subject in quite the same way, even when we are attempting a drawing from direct observation. Our choice of size, viewpoint, medium and technique gives the work a degree of individuality, even here. But we can go further than this: we can select and emphasize those features and characteristics of the subject matter which appeal to us most. Often we are inspired by a subject for a particular reason. We are struck by its dramatic qualities of light and dark, for example, or its interesting shape and form.

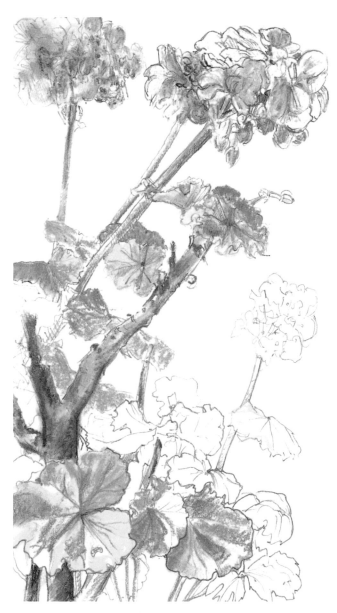

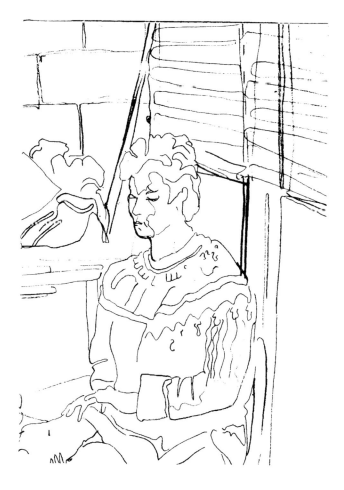

■ Illustration 82. Your interpretation of a subject may well depend on emphasizing a certain feature or aspect, and in turn this will rely on choosing the right medium and technique, as in this pen and ink line drawing.

■ Illustration 81. Drawings don't necessarily have to be highly finished all over. With a complex subject, one possibility is to make a line drawing of the complete shape and then isolate a section for particular analysis.

Therefore we can stress those features in our drawing. We are in fact interpreting what we see, conveying by a process of selection what in our opinion is the essence of the subject.

It is easy to argue that all drawings involve selection to a degree. There has to be some simplification and selection even in the most objective approach. No one is capable of producing a perfect likeness. But, although we might decide to respond in a more

individual way to our subject, this will equally derive from first looking and understanding.

Inextricably linked with interpretation is the artist's choice of medium and technique. With an idea involving atmospheric and diffused colour effects, for example, soft pastels would be much more suitable than coloured pencils, which might give a more linear effect. Look at the figure drawing in illustration 82. Although this is confined to the selective use of line, there is a successful impression of form and space and an interesting composition and interplay of different shapes.

Feeling

Drawings can also show mood and emotion and be created in a subjective and expressive way. The vigorous drawings of Van Gogh, for example, are charged with great passion and feeling.

The ability to draw with this sort of freedom and sensitivity usually evolves only after a great deal of practice and experience. You need to be accomplished in and confident with different techniques and be able to react to a subject in a spontaneous way – as opposed to the 'matter of fact' approach of an objective drawing. You have really got to be excited and inspired by an idea; you must really *want* to draw it.

Lively drawings of this type seem to imply a quick method of working and a sort of outpouring of inspiration. This is largely true. Equally, you will not respond to every subject in a

■ Illustration 83. The overall sense of mood and feeling of a landscape subject is often the most important aspect to consider, rather than aiming for a detailed description. *Black wax crayon.*

passionate way. In many of your drawings you will be looking for a more straightforward approach. But there will be times when you are moved to this sort of response and will want to experiment with a 'looser' technique.

Medium, subject matter and individual artistic style each play a part in creating drawings with feeling. Any medium can be used sensitively and expressively but you may find some media, like pastel and charcoal, less inhibiting than others. Be prepared to experiment occasionally. Similarly, try a variety of subjects and ideas. A derelict industrial landscape, for instance, can be just as inspiring as a moonlit lake. And don't worry about finding a style – this will come in time. Your style will be influenced by a wide range of things, perhaps from your study of other artists' work or the particular medium and methods you most often use.

Sketching techniques are a great help in developing quick and spontaneous ways of drawing. Chapter 8 deals with these in more detail. Compare the two location landscape sketches shown in illustrations 83 and 84. Here I have focused on capturing the mood and feeling of the scene, rather than any detailed description.

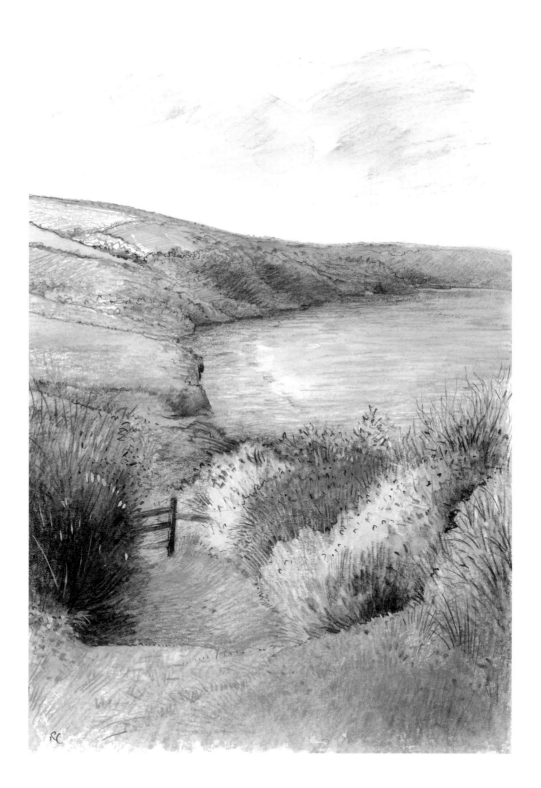

■ Illustration 84. An alternative study to illustration 83, this time drawn in the spring, when colour is an important feature of the scene. *Graphite and coloured pencils.*

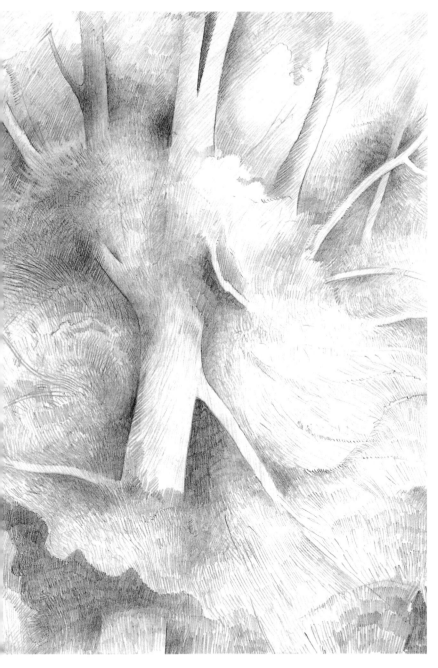

■ Illustration 85. Occasionally a subject will suggest a more stylized approach, perhaps involving the simplification of shapes and a certain technique, as here.

Developing

Sometimes the subject before you acts as a sort of starting point or trigger for a more stylized, imaginative or even abstract approach. It provides you with the basis of an idea that you can develop or interpret in an extremely individual way. You might emphasize or exaggerate, distort or simplify. You could decide to use an unusual viewpoint or work in a limited colour or tonal range. There are many possibilities.

Such drawings often result from an intellectual process, that is applying theory or restriction to the way that the work is developed. If you look at the drawing of part of a tree in illustration 85 you will see that I have simplified the shapes to create a strong composition, and thereafter have concentrated on using a hatching technique to develop the tonal effects. In other words, I have set distinct aims and limits for the drawing.

Exercises

1. Work from a flowering pot plant. Draw from direct observation, making two drawings, each from a different viewpoint. If it is a complex or large plant, concentrate on two different parts of it. Aim for carefully observed drawings which you could send to someone else to show them exactly what the plant looks like. Look again at illustrations 78, 79 and 81.
2. Now try a contrasting approach. Make a third drawing with a stick of charcoal or pastel working freely and vigorously and aiming to express the general characteristics of the plant.

Perspective and proportion

As explained in Chapter 4, one way of creating the illusion of a three-dimensional object on a flat sheet of paper is to use tone. However, as well as drawing convincing solid-looking individual shapes, artists also have to deal with the challenge of suggesting space, depth and distance in their pictures and assessing the relative proportions of one thing to another.

So, to make truly realistic drawings you will need to understand perspective and must learn how to check proportions, draw foreshortened shapes and imply distance through changes of scale. Colour and detail can also play a part in making your drawings look three-dimensional. For example, strong colours and details tend to stand out and consequently will attract attention in a drawing, which means, in practice, that these will be confined to foreground shapes. Therefore, when you are drawing, you should gradually weaken the colours and reduce the amount of detail as you consider shapes further back in the picture.

Perspective

Perspective is a drawing device that helps you suggest depth and space, particularly in relation to straight lines and parallel lines that go back into the distance. However, while the theory of perspective must be thoroughly understood, most artists do not draw with

■ Illustration 86. Note how parallel lines appear to get closer together as they go into the distance.

drawing

lots of vanishing points and parallel lines, for this would make their drawings look rather artificial and mechanical. What they learn to do instead is to draw with a consciousness of perspective – knowing what it does and how it affects certain shapes. Guidelines can sometimes help, but they need not be drawn with laser precision once you have understood what happens in perspective.

If you look at illustration 86 you will notice that the railway lines recede into the far distance. They are parallel lines, yet they appear to converge to a distant point. This demonstrates perspective perfectly: the basic principle is that receding parallel lines appear to converge, just like the railway track. Such lines are

drawn so that they taper inwards as they go back. If you were to draw them as they really are, in other words keep them the same distance apart, they would look as though they were going up in the air rather than going back into the distance: vertical rather than horizontal. The country lane drawing in illustration 87 is based on the same principle. Although in reality the sides of the road are not exactly parallel, they are more or less so, and the theory of perspective applies. Consequently the edges of the lane are drawn so that they get closer together as they recede. This gives a good feeling of distance.

This point is further demonstrated in illustrations 88 and 89. In the first, the box is drawn with its sides the

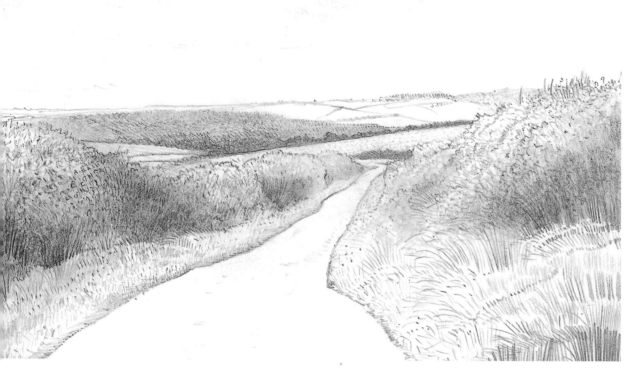

■ Illustration 87. Even when you are drawing a winding country lane you need to be aware of perspective. Notice how the edges of the lane are drawn so that they get closer together as they recede. This give a good feeling of distance.

■ Illustration 88.
Isometric drawing of a box.

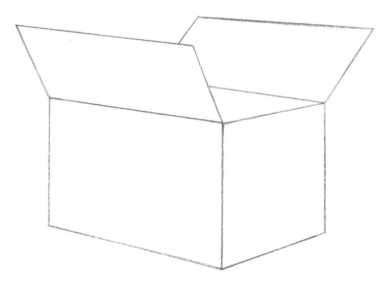

■ Illustration 89.
Perspective drawing of a box.

same width from front to back, which makes the top and bottom edges parallel. This is known as an isometric drawing – useful for designers, who need to give accurate measurements. However, in such drawings there is no sense of depth – in fact, the sides have an optical distortion which makes them look bigger at the back. In illustration 89 on the other hand, the box is drawn in perspective, and in consequence the sides taper slightly as they go back. This gives a much more convincing sense of form and depth. Notice that vertical lines are unaffected by perspective.

In connection with perspective, you should get to know these terms:

■ **Eye-level.** The actual or imagined horizontal line in a drawing which represents your line of vision in relation to the subject, i.e. the height at which your eyes observe the subject. To illustrate this, hold a pencil horizontally about 20 cm in front of your eyes.

■ **Horizon.** This is always at eye-level – the line where sky meets ground.
■ **Converging lines.** Parallel lines influenced by perspective; they appear to get closer together and eventually meet.
■ **Vanishing point.** The point where the lines of perspective seem to meet.
■ **Centre of vision.** The point on the horizon immediately in front of you as you make the drawing. This is not necessarily the middle of the drawing, because your viewpoint could be from one side.

You can see how perspective affects the shape of things by studying illustrations 90 and 91*a–d*. In illustration 88 the table is drawn in what is known as 'one-point' or 'parallel' perspective. Our viewpoint is directly on to one side and from the centre of that side. Note that lines in the drawing which are parallel to the edges of the drawing (that is, horizontal and vertical lines) remain parallel and unaffected by

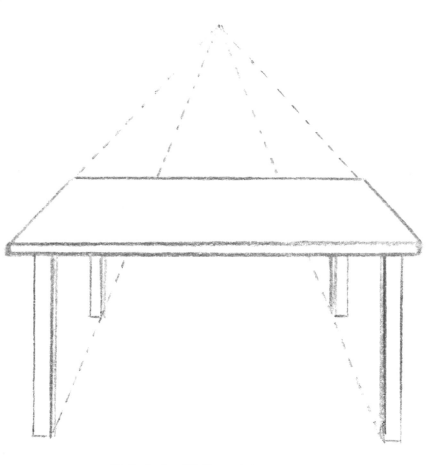

■ Illustration 91[a]. Perspective views of a house: close-up.

■ **Close-up view** 91[a]. Here the viewpoint is from normal eye-level but quite close to the building. The depth of the building is contracted or foreshortened and has to be suggested in a very limited space. The distortion of the sides is thus enhanced and the vanishing points consequently quite near the object.

■ Illustration 91[b]. Perspective views of a house: distant.

■ **Distant view** 91[b]. The further back we stand the less distortion there is: the sides slope back at less of an angle.

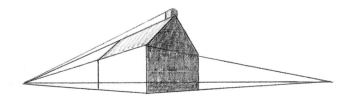

■ Illustration 91[c]. Perspective views of a house: worm's eye view.

■ **Worm's-eye view** 91[c]. If you squat down or take a very low viewpoint, your eye-level/horizon is consequently lower. The angle of the converging lines of perspective get steeper the further they are above the horizon.

perspective, which only influences receding lines. Therefore, only the two ends of the table are affected, causing the size of the back legs and the far side to appear smaller than those parts nearer to us.

Now consider the alternative views of the house shown in illustration 91. Here we can see two sides of an object set at an angle to us. Both sides slope back from us into the distance and therefore both are influenced by perspective – in this case what is called 'angular' or 'two-point' perspective. We have two sets of converging lines, with each set meeting at a vanishing point on the horizon or eye-level line. Look at each sketch in turn:

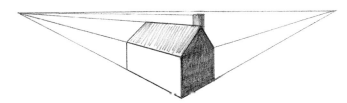

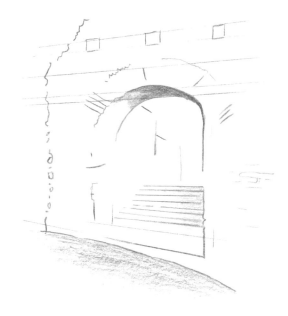

■ Illustration 91[*d*]. Perspective views of a house: bird's-eye view.

■ **Bird's-eye view** 91[*d*]. Similarly, if you look from a tall building or the top of a ladder, or work at an easel looking down on a still life group, your viewpoint is from above and the eye-level line is consequently high. So, you will see more of the tops of objects.

The best way of appreciating these points is to make some drawings of your own. Exercise (1) on page 73 will give you some ideas.

Remember to use perspective on objects which have straight lines or parallel sides running back into the distance. This could be a building, a brick wall, an arch, a gate, a road, and so on.

Normally you won't draw in the lines of perspective, but you could use a few guidelines. If you were to construct every drawing accurately, as in illustrations 91*a–d*, then you would either have to scale the objects down tremendously in order to fit all the vanishing points on your paper, or you would have to use enormous sheets of paper! But where you have a subject which is obviously influenced by perspective, give some thought as to how lines converge and how this will help you suggest depth and dimension, as in illustrations 92 and 93.

■ Illustration 92. With any building set at an angle to you, draw a few guidelines to help you fix the angles involved.

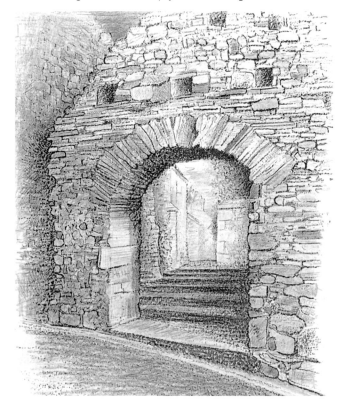

■ Illustration 93. Once you are sure about the angles and main shapes, complete the drawing in the way you wish.

Comparing shapes and sizes

Imagine your sheet of drawing paper as a kind of window frame or the proscenium arch of the theatre. The viewer will look into your drawing in the same sort of way. Therefore, you have to create the illusion of space and depth. Like the set of a traditional stage play or the backdrops of a music hall, think of your drawing as having a series of vertical, receding picture planes. So, as you build up the drawing you need to be constantly aware of how the part you are working on relates to the rest of the composition. You must get each part of the drawing in the right scale and the right place. Therefore, you must make frequent cross-references.

One way of checking relative sizes and positions is to use your pencil as a measuring stick. Hold your pencil at arm's length and keep your arm straight. With one eye closed, line up the pencil with the edge, distance

■ Illustration 94. A simple card viewfinder.

or angle you wish to check. Align your pencil so that its end corresponds to one end of the distance to be measured, using your thumb to mark the other end. Keeping your arm straight, you can now compare this measurement or angle with a similar or relevant one somewhere else in the composition. In this way you can make a series of comparative checks and measurements to help you draw things in the correct relative scale.

An alternative is to use a viewfinder which incorporates a grid, as in illustration 94. This is made as a cardboard frame with an aperture of, say, 10 cm × 14 cm. You can use clear perspex in the opening, with the grid lines drawn on, or make the grid by gluing lengths of cotton to the back. The squares on the grid will help you estimate where one shape comes in relation to another, and they could correspond to similar, though larger, squares on your drawing paper. Hold the viewfinder at arm's length in one hand while you map in the essential lines of your drawing using the other hand. You may need to have smaller or larger viewfinders depending on the subject matter and the scale of working.

In many individual subjects, like the human figure, it is essential to estimate the scale of one part correctly in relation to the rest, in other words to get it in the right proportions. Get used to looking at things in this way and noticing whether one part is bigger or smaller than another, and if so by how much. You can use the pencil measuring technique to compare different sizes. As you gain experience you will begin to assess proportions automatically in the way that you look and analyse. The more you practise drawing something, the more you will appreciate the proportions involved. This especially applies to the human form. While you should not become lured into the false assumption that every human being fits a certain formula regarding scale and proportion, you can use truths about average people as a guide.

For example, you will notice that the height of the average person is equivalent to 7.5 heads, and that

the various contrasts of scale and tone add interest and variety to the drawing.

The position and scale of things is very important when you have to deal with an unusual or exaggerated viewpoint, like something which juts straight out at you. In this case, because of its relative position to you, the size and shape of the object may be greatly distorted or condensed, an aspect of drawing known as 'foreshortening'. So, if you want to convey a lot of distance in a very confined space, you need to use an emphasised perspective. Look at illustration 96 to see how these points apply. The lamp on the left is pointing away from us and consequently the lampshade is relatively small in relation to the rest because it is the furthest part from us. Contrastingly, in the right-hand lamp, the lampshade is closest to us and appears much larger.

■ Illustration 95. To help with the proportions and pose of a figure, draw a sort of matchstick framework first.

dividing the height into 'heads' helps you fix other positions and proportions. With moving figures you might evolve the final drawing from quick matchstick or skeleton sketches, like those shown in illustration 95. These can only be drawn quickly and convincingly if you have a knowledge and understanding of basic proportions. Similar points apply to drawing the head. From a profile view you will discover that the head is quite square in overall dimensions, while from a frontal view it is more rectangular. You will notice, too, how all the features fit into the lower half of the head. See also illustration 54.

In some views, changing scale and proportions are linked to perspective. Together they give a tremendous sense of distance. This can be further enhanced by the way we use tone and colour. Usually weaker tones and colours are used in the distance and stronger ones with bolder lines for foreground detail and emphasis. Illustration 97 combines all of these methods and you will see that as well as creating a good sense of depth,

■ Illustration 96. Occasionally you will have to deal with an exaggerated or unusual viewpoint, for example when part of an object juts straight out towards you. Note that the lampshade on the right, which is pointing towards us, appears much larger than the one of the left, which is pointing away from us.

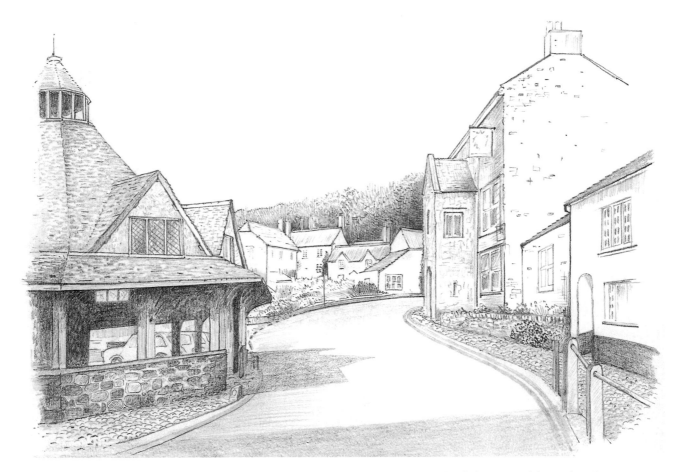

■ Illustration 97. A view of a street could involve all kinds of angles. Fix one or two 'key' shapes and then relate the others to them.

Making your drawings fit the paper

Proportions and scale also apply in a general way, of course, to the idea or composition and its relative size to your sheet of drawing paper. Here, some initial planning and consideration are important, otherwise you may find to your disappointment that you are well advanced with a drawing which is not going to fit your sheet of paper. In most cases you will be scaling down subject matter to fit your drawing. This involves keeping everything to relative proportions while reducing the overall idea to an acceptable size.

A reliable way to work is to start from the centre of your subject matter, matching this to the centre of your drawing paper. Take one or two general measurements using the pencil or viewfinder technique described earlier in this section. A couple of freehand diagonal lines will give you the middle of your sheet of paper and you can gradually plan out the main shapes from there. Within your chosen subject matter, start with the object nearest the centre. Once you have estimated the proportions of this in relation to the dimensions of the complete idea, you can sketch it in based on similar proportions in relation to the size of your paper. Sketch in the main shapes lightly and roughly at first. If everything seems to fit,

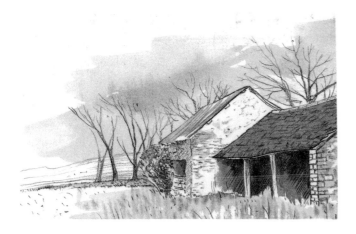

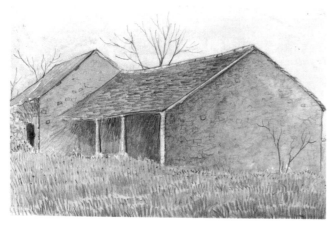

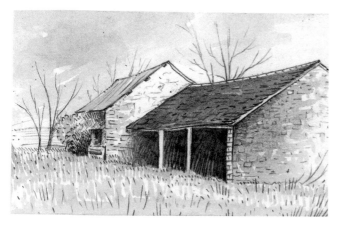

■ Illustration 98. How you place the subject on the paper can make all the difference to the final impact of the drawing. Which one of these drawings works best?

go back and check proportions and shapes more carefully. If the size of your preliminary sketch was too big or too small, then obviously you can adjust it accordingly.

Look at the sequence of sketches shown in illustration 98. You will notice that in the first sketch the building is crammed into the bottom right-hand corner and consequently does not make a very comfortable-looking arrangement on the paper. The next sketch is more effective in placing the building, although it fills the whole area of the paper and there is no sense of space. The final sketch works best. There is a much better feeling of depth and the composition is far more interesting and successful.

Exercises

1. Take an ordinary cardboard box, such as a breakfast cereal box. Place it on a table, on its side or upright but at an angle and about one metre away from you. Make three outline drawings from different viewpoints. Next, place the box on the ground and try a bird's-eye view perspective drawing. Refer to illustrations 88–91(*a*–*b*).
2. Ask someone to stand in an open doorway so that you can also see into the room beyond. Taking the doorframe as the boundaries for your drawing, make a drawing of the figure and anything seen in the background. Aim for a drawing which gives a good sense of space and depth. Use the doorframe to help you check the size and proportions of the figure and also relate its scale to the objects beyond.
3. In your sketchbook, and working on location from an actual example, make a drawing of part or the whole of a stone or brickwork bridge. Choose a viewpoint that shows some of the underneath of the arches. Try a colour drawing technique such as pencil and wash for this project.

8

Keeping a sketchbook

A sketchbook is an essential item of equipment and something which you should use frequently. In your sketchbook you can 'think' with your pencil, solve problems, and store useful information. Generally speaking it is not the place for highly finished drawings.

Ideally, to keep 'in trim' and have plenty of practice, you should draw every day, even if this is only for a few minutes. Your sketchbook will suit these daily practice sessions just as it will come in handy for research, ideas, thoughts, jottings, experiments, problem solving, notes, planning, roughs and so on. Use it purposefully: sketching is one of the best ways of keeping in touch with drawing and aiding your improvement and development. And, as always, don't be afraid to try out fresh ideas and use different media and methods in your sketchbook. You will see from this chapter just how valid sketching is and what a variety of techniques you can use.

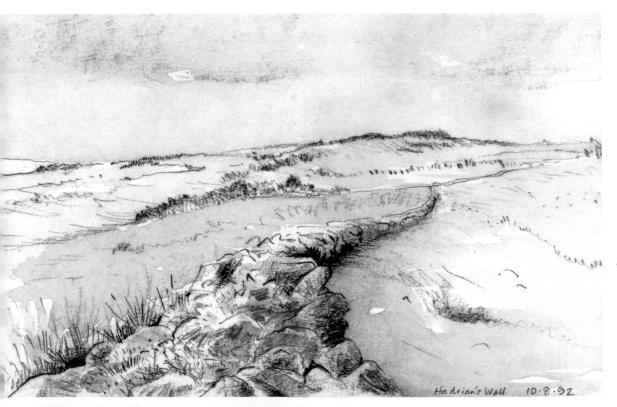

■ Illustration 99. Your sketchbook is your personal visual notebook – somewhere for ideas and information. For your own interest, jot down the place and date on each sketch. *Charcoal and wash.*

Hadrian's Wall 10·8·92

Choosing a sketchbook

Sketchbooks are sold under a variety of names: sketch blocks, drawing pads, layout pads, and drawing books, for example. To begin with, buy an A4 spiral-bound cartridge paper sketchbook for general use and a small, pocket-size one to jot down those unexpected ideas, notes and flashes of inspiration. Cartridge paper is fine for most media and techniques but, as your work progresses, you may find that you need a certain type and size of sketchbook which better suits a particular medium and way of working. For example, if you work mostly in pen and ink you will find that the smooth paper in a layout pad is best. You can also buy sketchbooks consisting of sheets of watercolour paper (for brush and wash ideas), and coloured pastel paper (for chalks, pastels, charcoal and other soft medium techniques). Remember that the type of paper will influence how the medium responds, so think carefully about the kind of sketchbook that will suit you best.

An alternative is to make your own sketchbook using an A4 ring binder and loose sheets. The advantage here is that you can insert sheets of different types of paper and therefore use a whole range of media and techniques.

Ideas and experiments

Your sketchbook is your personal visual notebook. You will not have to show it to anyone else and therefore you can work without inhibition. Don't be afraid of making mistakes or 'bad' drawings. This isn't the place for highly finished work. There may be lots of ideas which simply do not work, but this is one of the main purposes of the sketchbook – to thrash out ideas and solve problems so that you avoid mistakes elsewhere.

If you are planning a holiday, visiting somewhere, having a day out in the country, or going anywhere that looks potentially promising from a drawing or ideas point of view, then take your sketching things

■ Illustration 100. When sketching outside you will probably need to work quickly, so choose a technique you are confident with.
Pen and ink.

with you. Ideas abound, are often unexpected, and can present themselves in the most unlikely places. Jot them down in your sketchbook, and in this way build up a collection of reference and outline ideas which you can develop later. For your own interest, make a note of the place and the date, as in the sketch shown on page 74.

■ Illustration 102. Many sketches will also work as effective drawings in their own right.
Fibre-pen and wash.

■ Illustration 101. Sketches are a good way of gaining an understanding of the subject before you start on a more detailed drawing. *Charcoal.*

As well as trying out new media and techniques in your sketchbook you can use it to get a feel for a subject before you start on a highly-resolved study. Learn to introduce yourself to subjects and ideas by this means, as demonstrated in the drawings in illustrations 100 and 101. Quick drawings similar to these will help you assess a subject and its likely problems and encourage you to look and think. Note also the different techniques used here: a mapping pen in illustration 100 and charcoal in illustration 101. Charcoal is an ideal medium for quick results, as are some of the line techniques explained in Chapter 3. Many sketches will also work well as effective drawings in their own right, see illustration 102.

Illustration 103. Location sketch, stage 1. Block in the main areas, working quickly. *Coloured pencils.*

Drawing and research

Quite often you will need more than the bones of an idea – you need good reference material from which to work. Therefore, your sketchbook can also be used for making careful studies, researching form and movement, exploring different viewpoints, and showing texture, structure, details and colour reference. You can work up a final study from a number of sketches, like those shown in illustrations 98, 103 and 104, while some analysis, as in illustration 105. will enable you to fully understand the structure and form of something and allow you to complete the main drawing with confidence.

Your sketchbook will be more interesting and useful if you try out different media rather than just use pencil. Pastel is good for quick colour studies, charcoal excellent for broad tonal work, and there is a variety of

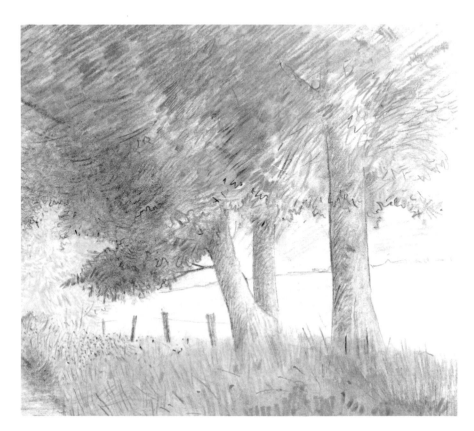

■ Illustration 104. Location sketch, stage 2. Develop the drawing, as time permits, until you have the amount of information you need. *Coloured pencils.*

free-flowing fast-drying pens to choose from for line work. Additionally, you can combine pen and pencil techniques with quick brush and wash effects, either in tone with diluted Indian ink or in colour with watercolour or thinned coloured drawing inks. Water-soluble pencils are ideal for colour sketches which need to incorporate line and solid colour or wash effects.

Much of your sketching will be done out-of-doors, concentrating on subjects such as landscapes, buildings, street scenes and harbours, and so on. Here is a reminder of what you might need for sketching trips:

- Sketchpad or drawing board and paper.
- Pencils, pens, charcoal, pastels and other colour media such as water-soluble pencils.
- Small screwtop bottle of water, brushes, cloth, craft knife, eraser, bulldog clips to hold down paper, fixative.
- Folding stool or something to sit on.
- Rucksack or similar to carry everything in.
- Suitable clothing, food and drink.

Be adaptable and prepared for changes in the weather. If you are unable to find or draw exactly what you intended, then try something else. For example, if your challenging landscape view is obliterated by a sudden rainstorm, then look for a sheltered spot and make some individual studies of clouds, trees or other aspects of the landscape. And don't expect sheep and other animals to stand still! Instead, you may have to work on several sketches at once. If an animal changes its stance after you have started sketching, then simply begin another drawing, showing it in the new position.

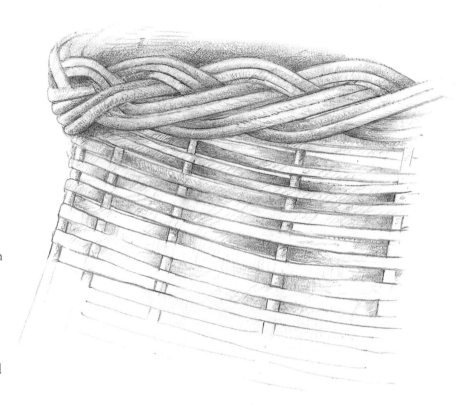

■ Illustration 105. Your sketchbook can also be used for the occasional more detailed, analytical study, or to try out different media and effects. *Pencil.*

You can return to the original sketch if that animal, or another one, resumes the pose you began with.

You will normally have to work quite fast when sketching outside, so it is wise not to waste time on aspects of the subject which you can easily remember or which you can jot down in note form. Stick to an approach that focuses on the essential information about the main shapes and characteristics of the subject. Think of the sort of angle or viewpoint you want and choose a sketching technique that suits the effect you are after and, at the same time, allows you to work quickly.

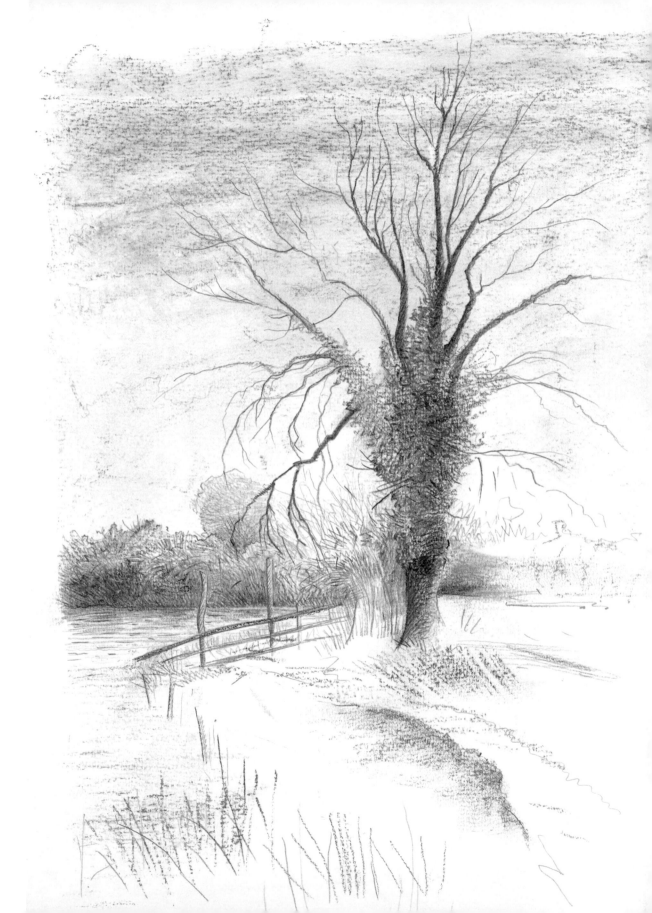

■ Illustration 106. There won't always be time to finish a drawing on the spot, but once you have got to a certain stage you will be able to finish it later, at home. If necessary, take a photograph to remind you of the scene. But work from memory rather than trying to copy the photograph. *Coloured pencils and pastels.*

Notes and photographs

You can supplement any sketches, research studies, experiments and details with written notes. Sometimes there just isn't enough time to jot down everything you need to know in the form of drawing and you may, for example, be restricted to black and white when you need some colour reference. If so, do as I have done in illustration 107, add a few words to your drawing to remind you of things.

Photographs provide another form of reference. Again, you may run out of time, need something in colour, want a particular detail, or would benefit from a range of viewpoints and different composition suggestions. But look on photographs as an aid to your drawing rather than something to be slavishly copied, and whenever you use them, try to ensure that they are your own. If you were the photographer it means that you have witnessed the actual scene or subject and consequently you will be able to support the information provided by the photographs with your own recollections and feelings about the subject. Remember that you should never aim to recreate a photograph, and that you must be sensitive to the drawing media and processes involved. You can use photographs for:

- **Additional reference.** As a general reminder of the subject or a piece of specific information which you could use in part of a resolved drawing later on.

- **Starting points.** As the basis of an idea which you can develop or interpret in your own way through a drawing.
- **Fleeting moments.** For action subjects such as a speeding car or someone diving into a swimming pool. You simply would not have time to sketch these subjects effectively.
- **Composition aids.** To provide you with a number of different viewpoints and suggestions for composition alternatives.

Bear in mind that photographs usually distort distance, perspective and colour, and so they cannot be relied upon to be truthful. This is one reason why you should not copy photographs. But equally important is the fact that simply reworking an idea from a photograph is likely to result in a dull drawing, no matter how technically sound it may be. Drawings need an element of spontaneity and discovery: you shouldn't know all the answers before you start!

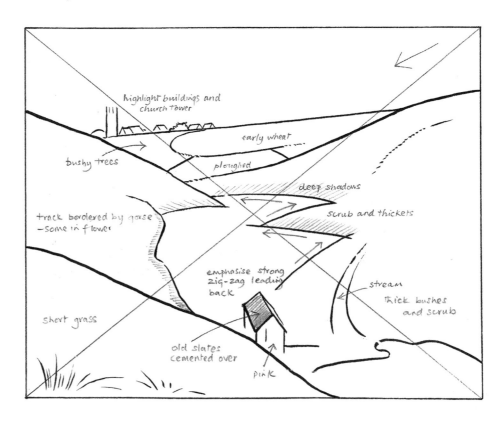

■ Illustration 107. Brief location sketch with added notes. *Felt-pen and pencil.*

Exercises

1. Choose an out-of-doors theme which appeals to you. For example, this could be buildings of local interest, tree forms, animals, people shopping, or cloud effects. Over a period of time, make a series of drawings in your sketchbook which will help you compose a well-finished, studio-based drawing later on. Collect different views and ideas and use several techniques including colour.

2. Make a sequence of sketches on the theme of water.

3. When you are next out for a day in the country, try making one or two general view sketches, like illustrations 99, 102 and 104.

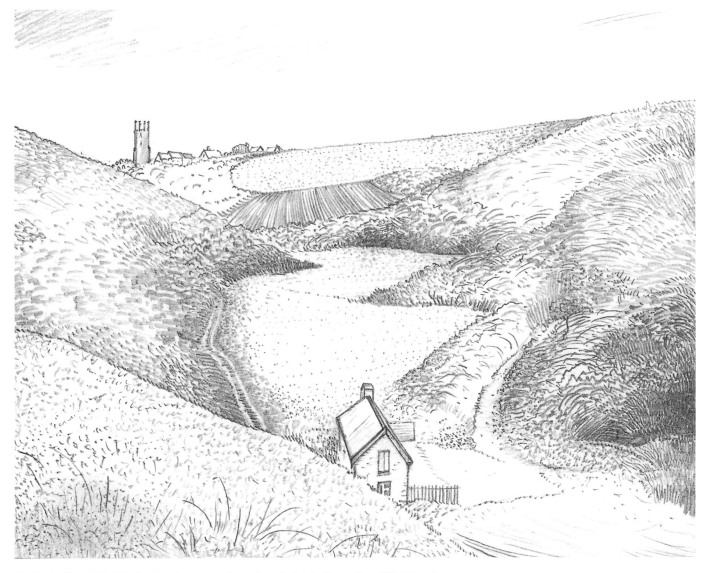

■ Illustration 108. Studio drawing made from the sketch in illustration 107. *Pencil*.

9

Ideas and inspiration

Handling materials, experimenting with techniques, using perspective, and discovering how to look and see are all essential basic skills when you are learning to draw. Now that you have some knowledge and experience of these foundation skills you should be able to tackle more varied and challenging subjects with some confidence.

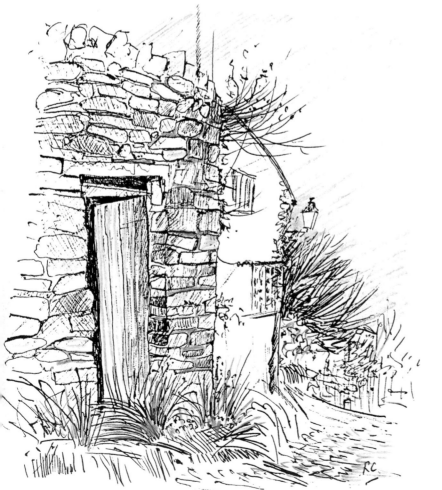

In drawings, as in any other type of skill, the learning process is continuous: there is always something new to learn. So, through practice and application, and by confronting new ideas and finding better ways of expressing yourself, your drawings will slowly improve and develop. With increased experience you will begin to establish a particular direction in your work, perhaps an approach, technique or subject matter that appeals to you most. You can build on this interest and gradually evolve a style of your own – a way of seeing, interpreting and drawing which is stamped with your individual personality.

In the remaining chapters of this book you will see how to make the most of your ideas through selecting and composing, how to plan work thoroughly, and how to develop your ability and find your own means of communicating and expressing using the powerful medium of drawing.

■ Illustration 109. A location sketch made with pen and ink and coloured pencils.

■ Illustration 110. Quite often the characteristics and qualities within the subject matter will suggest a means of interpretation and the best medium to use. The defined, linear shapes of these winter trees, for example, inspired a pen and ink approach, adding a hint of the colour values later with one or two weak washes of watercolour.

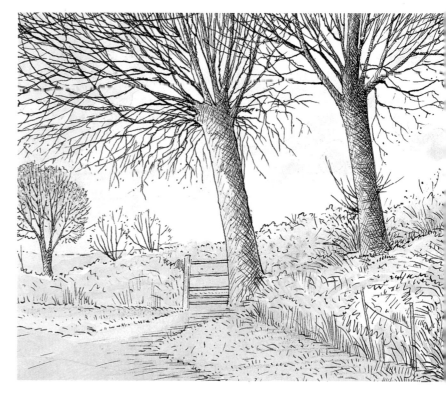

What to draw

Draw anything and everything! Although you will have your own views about suitable subject matter, avoid getting too narrow-minded and playing safe. You might be moved by the drama of a sweeping landscape or the subtleties of light and dark in a group of objects, the excitement and bustle at a busy railway station or the quiet simplicity of a corner of your garden. The scope is boundless – there are ideas everywhere! Naturally, you will want to choose subjects and themes that excite and interest you. But every drawing needs to be something of a challenge, so avoid repetition. If you have proved that you can draw a particular thing well and have said what you needed to say about it, why draw it again? Repeating something because you know it will work will only lead to tired and uneventful drawings. Look for alternative viewpoints, different techniques, other ways of doing things. If the drawing demands something new of you, it will not only be more likely to succeed, but will also add to your experience and general development. Even if you never tire of certain themes, you must be able to view them each time with a fresh eye and so keep the drawings vital and lively.

You can find ideas and inspiration in the most unlikely places. Look at the range

■ Illustration 111. This speedy, feely-expressed location sketch was drawn with charcoal.

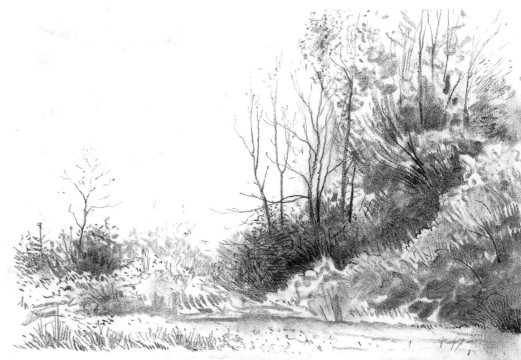

■ Illustration 112. When you are outside with your sketchbook try drawing a wide variety of subjects. These will all help in developing your drawing skills. *Pencil and wash.*

■ Illustration 113 (below). You won't need to search for subjects to draw – they are all around you. Even an everyday scene such as this can make a challenging and interesting drawing. *Pencil.*

of ideas shown in illustrations 109 to 116, for example. Possibly not all of these subjects will appeal to you, but they do hint at the variety of things to draw and the different methods and media that can be used. In some subjects it could be the relationship of shapes and tones that attracts you, while in others you might see the potential for using a particular medium, approach or technique. You could decide to make a detailed study of part of a very complex form, or find that simple, commonplace subjects will also inspire lively drawings.

You are more likely to make a good drawing if the subject is something that you really want to draw rather than one you feel you ought to draw. If you have any interests and hobbies it may be possible to develop them further through drawing. A fascination

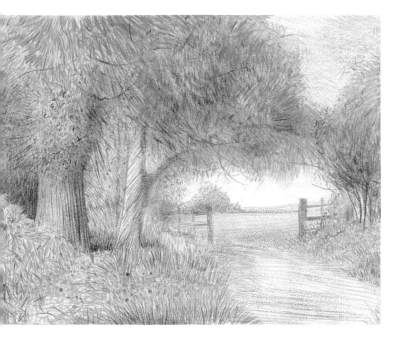

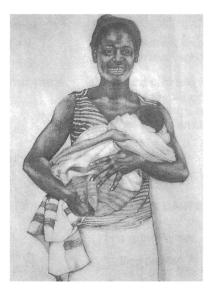

■ Illustration 116. You will find that in many drawings what you feel about the subject is just as important as creating a good likeness. In this drawing, for example, which was made by a student from the Mzilikazi Art and Craft Centre, there is a very convincing sense of a loving, happy mother.

■ Illustration 114. The surface of the paper plays an important part in creating the kind of effects you want. This landscape drawing was made on a medium quality watercolour paper which had a slightly rough surface and so allowed various textural effects to be incorporated into the drawing. *Coloured pencils.*

with and knowledge of your subject matter will help you draw it well. So if you are a keen long-distance walker, for example, or a Grand Prix enthusiast, take along your sketchbook and get some ideas to develop.

We have seen that artists draw almost anything and that the classification of subject matter can range from detailed realism to abstract and embrace ideas developed from fantasy and imagination through to various interpretations of natural forms, still lifes, landscapes, figures and portraits. As well as from your own thoughts, ideas, and sketches, you can be inspired by the work, techniques and subject matter of other artists, or find general ideas to develop from photographs and similar visual aids. To begin with, try to gain a wealth of experience by attempting as many different types of subject matter and ideas as you can. From the variety of illustrations in this book you will see that there are all kinds of exciting things to draw.

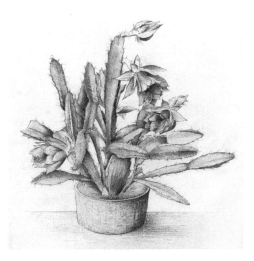

■ Illustration 115. Try one or two closely observed and detailed studies like this now and again. Such drawings are helpful not only in training your observation, but also in developing technique and drawing skills. *Pencil.*

Exercise

1. Study the drawings shown in this chapter and then select three different themes for drawings of your own. Work in a colour medium for at least one of your drawings.

■ Illustration 117. Line drawing: evenly balanced design. *Fibre-pen.*

■ Illustration 118. Pencil study alternative to illustration 117, introducing a more obvious focal point as well as the added interest of tone and texture.

Composition and viewpoint

Whatever the appeal of a subject, to succeed as a drawing it must somehow involve an interpretation that is founded on a strong and visually pleasing structure or composition. For, as well as providing the 'scaffolding' to help build and develop a drawing, the composition plays a vital part in creating interest and impact.

You will remember from Chapter 7 how important it is to plan you drawing so that it fits the paper. No matter how expert you are with materials and techniques, the success of a drawing will be drastically reduced if it has been neglected or ill-considered from the design point of view. But more than just getting the scale right and making sure parts of the idea do not disappear off the edges of the paper, good design will aim to add to the drawing's overall effectiveness. In fact, it could well be the key factor in creating an eye-catching and original result.

In designing, you are composing with different shapes. You are deciding how best to arrange these shapes in your picture area, what viewpoint or angle to use, how to contrast bold, general areas with smaller, detailed ones and so on. And as you draw, so you have to bear in mind that the distribution of tones or colours, the media and techniques being used, details and textures, and what you wish to emphasise and focus attention on, are all interrelated to the overall design or composition. Even if you are drawing just a single object, you will need to consider its size and position against the background area. So, design relates to the whole sheet of paper and in the design process you will need to think carefully about the way the positive elements (the main shapes and subject matter) are related to the negative ones (the background shapes and spaces).

Some of these points are demonstrated by comparing the two drawings in illustrations 117 and 118 (left), which have the same basic design. In the line drawing, illustration 117, the almost evenly distributed weight of the design is more noticeable than in illustration 118, where the addition of tone and texture disguise it. Notice also that the inclusion of the pendant lamp in the upper left-hand corner has created an obvious focal point as well as a shape that contrasts with the rest of the composition, thereby making a more interesting drawing.

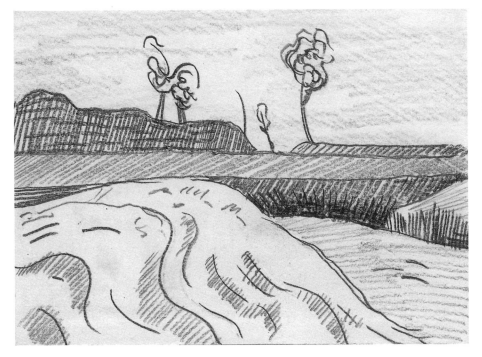

to draw with an awareness of these factors rather than a complete conformity to certain rules and procedures.

Drawing requires constant thought: with composition you must be fully aware of planning and design and have reasons for your decisions. One way of helping your own deliberations about composition is to study the work of other artists. Have a look at some drawings by well-known artists – there are some in this book. Look at the way they have composed the work, how they have made the drawing interesting and exciting, whether they have used a focal point or part of the drawing to particularly attract your attention, and so on. There is more about looking at drawings in Chapter 13. If you can ask and answer the same questions for your own drawings then you will be well on the way to success.

In dividing up the picture area into various shapes and spaces we are once again concerned with proportions. Generally speaking, a drawing which uses identical, balanced or totally symmetrical proportions in its basic composition will have far less overall impact than one

How to make a good composition

Composition involves selecting and arranging in such a way that your eye is led around the drawing, your attention is kept within the picture area, and you focus on a particular point of interest. You will see that good composition can depend just as much on what you decide to leave out as on the way you organise and emphasise the remaining shapes. Once again, there is no magic formula for success! As with other aspects of drawing, the best approach is to study carefully the theory, advice and various considerations that apply and, while you are drawing, take these into account as much as you feel is necessary. Aim

■ Illustration 120. Composition sketch 2. Altering the viewpoint to create a less balanced and consequently more interesting composition.

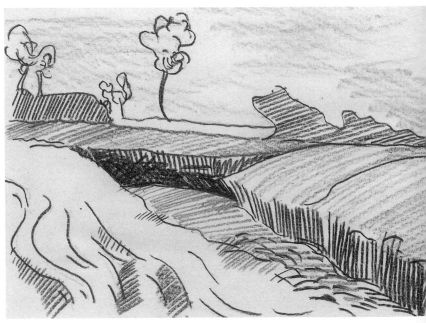

which does not. But, like any 'rule' in drawing, it is true that this one is frequently broken, and with much success, by many accomplished artists. Nevertheless it is usually best to avoid compositions which use equal splits of the drawing area, either vertically or horizontally. For example, this would apply to a landscape in which the horizon was placed exactly half way up the paper.

Thinking through a composition idea is best done with a series of quick, simple sketches, like those in illustrations 119 and 120. In the first illustration, the distribution of the main shapes, especially the horizontal lines through the middle and the position of the trees, gives a rather balanced effect. In illustration 120 on the other hand, the trees are confined to the left-hand side and the viewpoint has been altered somewhat so as to create a more flowing and imbalanced design. Use non-fussy media like charcoal or pastel for roughs of this sort. For easy comparison, they can be done as a sequence on a large sheet of paper, or you can do them in your sketchbook.

Try designs which exploit a diagonal or triangular division or consider the sort of basic proportion known as the 'Golden Mean' or 'Golden Section'. Devised by the great artists and mathematicians of the Renaissance and accepted as having special artistic significance and aesthetic value, this is an arrangement or ratio of proportion such that the smaller part to the larger is the same as the larger to the whole area. The ratio is approximately 5:8, although most artists prefer to think in terms of 'thirds', and so roughly two-thirds across the drawing they will place some significant feature of the composition. The division can be applied in either direction, horizontally or vertically. Look at the position of the tree in illustration 122, for example, and see if you can identify other drawings which use this principle.

Some other points to watch out for are demonstrated in illustrations 124–126. In 124 you will notice that the objects are in a straight row and that they are fairly

■ Illustration 121. Dividing a sheet of paper on the basis of the 'Golden Mean' principle, in the ratio of 2:3.

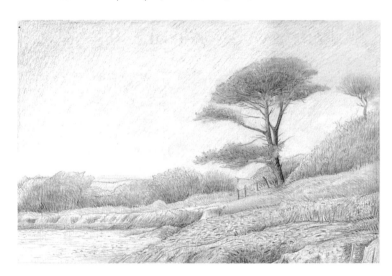

■ Illustration 122. A composition using the 'Golden Mean' proportion. Note the position of the tree and the horizon line. *Coloured pencils.*

evenly spaced apart. Additionally, the horizon line is straight across and, with the bottle in the middle, the general arrangement is quite symmetrical. These are all potentially negative points: things which do not contribute to the excitement or impact of the design. In 125 some improvements have been made. The

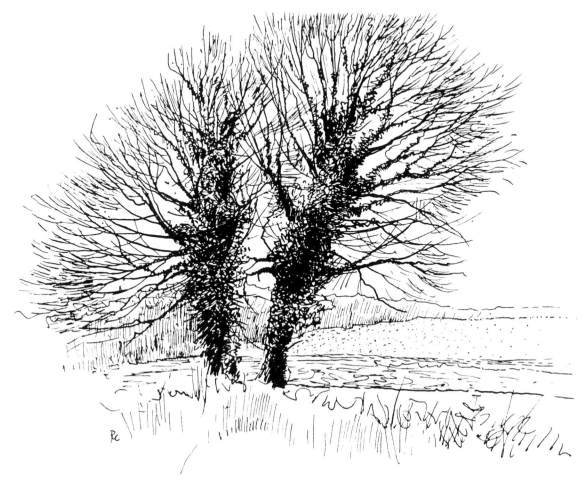

objects are not so spread out, but although the arrangement is more interesting the bottle is still very central and the bases of the objects remain level. Now look at the composition in illustration 126. Isn't this much better? There is greater movement and direction, more interesting spaces, and the general composition is now not so rigid and balanced. These are the sort of points to think about, not only when arranging a still life group, but regarding the selection and composition of any idea.

In all drawings try to ensure that the eye is led to a focal point or centre of interest. For example, in a landscape or townscape subject, the focal point could be a figure, while in an interior or still life it might be a particular object or even a patch of light. There are various 'rules' that you can bear in mind here also, as for example, not placing the focal point in the middle of the drawing and not using diagonals and other directional lines or sequences of shapes that carry the eye out of the picture area. In fact, the subject itself will often suggest ways of leading the viewer's eye around the picture and arriving at a focal point. A good composition will contribute to holding the viewer's attention and thus encourage them to look more and more at the drawing, thereby discovering new depths and qualities.

While the 'rules' of composition can be helpful, they should not become a rigid formula applied to every

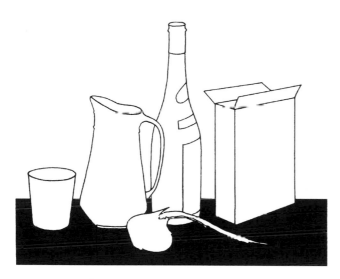

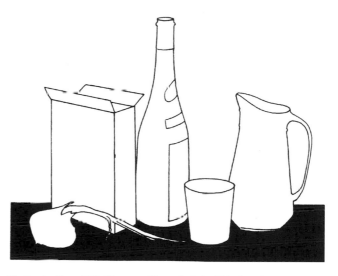

■ Illustration 124. Composition sketch. Notice that the grouping is rather equally spaced and balanced.

■ Illustration 125. Composition sketch. This is a better arrangement with more interesting spaces, although still rather symmetrical in the overall design.

drawing. With experience you will discover how to experiment with the relative weight and position of different shapes and how these must correlate with tone, colour, texture, line and other qualities. Composition is all about balancing one thing against another and you will soon find that there are plenty of exciting ways of creating order in a drawing yet at the same time directing the eye on an interesting journey around it. So don't be afraid to try different arrangements or to take a chance with the composition. And, as with the subject matter, there should be something about the composition that is discovered and developed in the drawing process. Simply working to a preconceived plan or structure can result in dull and uninspired drawings. You will need a combination of instinct and experience to decide how to organise the composition such that it presents the subject matter in a way that can be clearly understood by others yet is exciting and original.

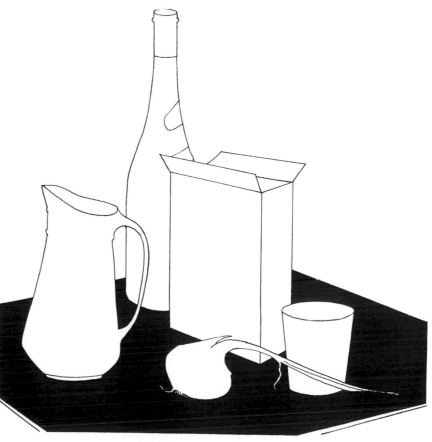

■ Illustration 126. Composition sketch. Here there is more movement in the design and the grouping is generally more exciting. *Fibre-pen.*

Summary points

- Use simple roughs and diagrams to plan your composition.
- Consider the size, shape and best way round to use your paper.
- Think about the contrast between sizes, shapes and spaces, as well as movement and direction.
- Avoid basic divisions which will make your composition too balanced or symmetrical.
- Use lines and shapes which lead to a main focal point or centre of interest.

Using a viewfinder

Some subjects are complicated and extensive and you may find that it is very difficult to know which part to concentrate on for your drawing. Busy street scenes, panoramic landscapes, and general views fall into this category. A landscape drawing such as that in illustration 122 has to be selected from many

possibilities. The viewpoint and scope of the view are vital considerations in achieving a good composition.

To help you isolate parts of a complex subject in order to determine which area will make the best drawing, you can use a cardboard viewfinder. Make this by cutting an aperture of about 2 cm × 3.5 cm in the middle of a sheet of 10 cm × 13.5 cm thin card. Sizes can vary according to the scale of work. With one eye closed look through the viewfinder and move it around to compare views. Try it both ways round, i.e. landscape (horizontally) and portrait (vertically).

Cropping

The composition and the impact of the drawing can sometimes be improved by cropping. This means reducing the size of the drawing. Use two right angles of card like those shown in illustration 127. These can be moved around on the drawing to 'frame' the best section. The drawing is then trimmed to the desired size.

This is not a technique that should be used very frequently, but it can salvage some drawings that have run into problems with large, uninteresting or repetitive areas. An unexciting, large drawing can sometimes make two exciting small ones!

■ Illustration 127. Using two right angles of card to 'crop' a drawing.

Exercise

1. Using a cardboard viewfinder, go around the house and look for interesting corners and subjects to draw. Experiment with different viewpoints and with both 'portrait' and 'landscape' shapes. Make composition roughs of six different ideas. Evaluate the ideas and decide which composition works best. Enlarge it into a fully worked drawing.

Planning your drawing

The subject matter, available time and materials, and the general conditions and situation in which you are making the drawing will all play their part in influencing the sort of approach you adopt and the type of work envisaged.

While many sketchbook drawings might be made very quickly, perhaps in a matter of a few minutes, in contrast there will be other occasions when you will want to make large and highly resolved drawings. A complex drawing could take several days to complete and, to ensure its success, it will obviously require some careful planning and preparation. From your initial thoughts and sketches you may need to work through quite a few stages to reach the final result.

This chapter explains the process you will need to consider whenever you decide to tackle a resolved drawing of this type. However, do remember that in planning a drawing you must always strike a balance between the degree of preparation and working with complete spontaneity. You won't want to proceed with an ill thought out idea that leads to frustration and disappointment, but at the same time, try to ensure that the planning doesn't stifle the vigour of the drawing. Aim for clear objectives and intentions, and make careful decisions about scale, composition, techniques and so on, but always leave something to be discovered in the final stages of the drawing.

Planning your drawing

Look upon planning as a means of enquiry and decision making which, in turn, will lead you to the best approach to explore in your main drawing. Familiarise yourself with all the points listed below and get used to doing a quick mental check of these prior to each drawing. Not every drawing will need to evolve through all of these stages, of course, but you should be aware of the sort of factors to consider, because these influence the way that the work develops. Eventually you will start to follow this process of decision making automatically and more intuitively.

For studio compositions and major drawings you will need to consider the following stages of working:

- **Aims.** Your drawing is a visual statement, so what do you want to say? Think carefully about the subject matter and the sort of emphasis and impact you want to achieve. Make some rough plans and ideas.

- **Research.** Get what information you need in the way of sketches and studies. Decide which media and techniques will work best for the effects you want.
- **Composition.** Make some composition roughs to try out alternative ideas before finalising the design.
- **Preparation.** The paper may need stretching or preparing in some other way. Check that you have all the equipment and materials you will need to complete the drawing.

Whatever the subject matter you will find that you work more positively and successfully if you are trying to create something specific and have well-defined aims. If you know what you are trying to achieve in the drawing, you are more likely to achieve it! Your aim could be to make a carefully observed and detailed study of something, or you could choose a more emotional response, such as conveying your feelings about a stormy landscape. Equally, your objective could be to analyse, as in examining the relationship of shapes and tones in a particular subject, for example, or alternatively it could be concerned with a special technique or medium. It will set you a problem and focus your attention in a certain direction.

To help you decide on the best approach, begin with some simple sketches or 'roughs'. You can use roughs to:

- **Get you started.** For thinking on paper, brainstorming and experimenting with basic ideas;
- **Help you understand.** As preliminary sketches to familiarise you with the subject matter before tackling it in detail;
- **Select and compose.** As quick sketches of different parts of a complex subject to help you select an area for closer scrutiny in the main drawing; and as a means of trying out different design and composition alternatives;
- **Try out techniques.** Use quick sketches to test out the suitability of a medium for a particular idea or effect, or to check the compatibility of medium and paper or of different combinations of media.

Roughs are simple, small sketches – usually composed of just a few lines. You can make these in your sketchbook or as an easy-to-compare sequence on a large sheet of paper. As well as pencils, try using other quick sketching media, such as pastel, charcoal and felt-pen.

You will also need your sketchbook for more deliberate studies and research, especially when time and practical considerations prevent the main drawing being made in situ. In general, this will apply to complex scenes, locations or situations, any subjects that are moving or changing in some way, and composite ideas, that is drawings that are compiled from a number of different sources. If you wanted to make a detailed drawing of a bustling crowd at the races, for example, the best approach would be to work from sketches and reference photographs rather than attempt an on-the-spot finished drawing.

Refer to the section on drawing and research (see page 77) for some other ideas and information.

Your research can be in the form of:

- **Location drawings.** Use your sketchbook and make some drawings on the spot to give you a general idea as well as specific information about details, textures and features.
- **Preliminary studies.** Investigate different viewpoints, the sort of design and composition you want, and any 'awkward' parts of the subject before you begin the main drawing.
- **Using photographs and books.** This might be essential for imaginative ideas where first-hand reference is not possible. Remember that this sort of material is for reference rather than copying.
- **Inspiration from other artists.** Visit galleries and exhibitions to view drawings by well-known artists. Books and videos will also provide information. Studying the work of other artists is another way of increasing your knowledge and understanding of drawing and helping with your own ideas and technical problems. See also Chapter 13.

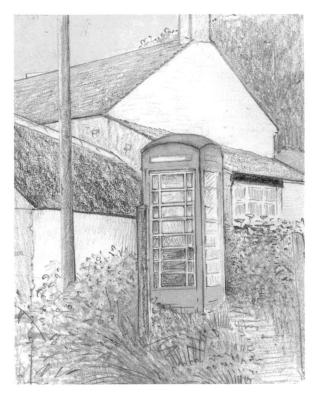

■ Illustration 128. Location sketch for colour reference. *Coloured pencils.*

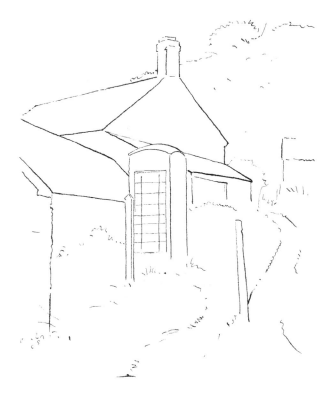

■ Illustration 129. Location sketch defining the general composition. *Pen and ink.*

Look at illustrations 128–130. Together these provide sufficient information from which to make a final, detailed study. The location drawings give two alternative compositions as well as some colour reference, while the photograph is a useful reminder about other details.

Enlarging and reducing ideas

Quite often the main drawing is worked up from a much smaller composition sketch and it is therefore important to ensure that the larger sheet of paper is in proportion to the smaller. The quickest way of doing this is to position the sketch on the larger sheet of paper so that the bottom edge of the sketch and its left-hand side are aligned exactly with those of the big sheet. If you now place a long straight-edge diagonally across the sketch from bottom left to top right you can extend this diagonal across the larger sheet of paper.

■ Illustration 130. Location photograph.

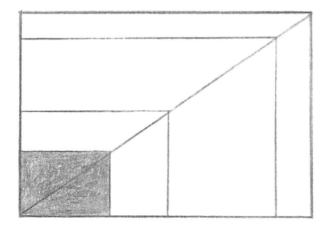

■ Illustration 131. Enlarging in proportion. Any rectangle constructed on the extended diagonal will be in proportion to the original shape (shaded blue).

Any rectangle constructed with its top right-hand corner on this diagonal will be in proportion to the original sketch. See illustration 131. You can, of course, scale down ideas simply by reversing the process.

It is not usually necessary to enlarge a rough idea very accurately, although you will want to get the general shapes and proportions approximately correct. The quickest method is to use guidelines drawn diagonally and to divide the paper in half in each direction. Do this with faint lines on both the sketch and the large sheet of drawing paper. You can see where the main lines and shapes of the drawing come in relation to these guidelines and so match them to the corresponding guidelines on the big sheet. If you do not want to damage the sketch, cover it with tracing paper before drawing in the guidelines.

For greater accuracy, use the squaring-up method shown in illustrations 132 and 133. Draw a grid of squares across the original drawing (or on tracing paper covering it). Measure along each side to work out how many squares to use. Avoid a large number of squares as this can complicate the process. If the drawing does not divide into an exact number of

■ Illustration 132. Squaring-up a drawing.

squares, don't worry, as the same will happen to the proportionally larger sheet. Draw a similar grid on the large sheet, using a corresponding number of squares in each direction. Look at the original sketch and, taking each square in turn, redraw the part of the drawing in that square on a larger scale to fit the appropriate square on the big sheet. Carry on with this process until you have completed the enlarged outline. You can then erase the unwanted faint grid lines.

Preparing the paper

Some artists like to have the paper loose on the drawing board so that they can twist it round and get at the drawing easily from any angle. Others prefer the

■ Illustration 133. Enlarging from the squared-up original.

If all you wish to do is lightly tint the drawing here and there with a little wash, then you need only 'dry-stretch' the paper – fix the dry paper to the drawing board with a strip of gummed tape along each edge. For wetter techniques you will need to follow the process set out below.

Preparing the paper – wetter techniques

1 The paper must be of a size which allows a margin of at least 4 cm all around on the drawing board. You will need a strip of gummed tape for each side of the paper cut to a length which is slightly longer than the paper.

2 Dip the paper in clean water so that both sides are wetted.

■ Illustration 134. Stages of stretching paper for use with wash and other wet techniques (a) wetting the paper.

3 Position the wet paper on the board. Then, working quickly, apply the wetted gummed strips to each edge.

■ (b) placing the wet paper flat on a drawing board.

paper pinned to the board or held with board clips or bulldog clips. Remember to use paper which is sufficiently large so as to allow for a margin around the edge of your drawing area – this gives scope for mounting the drawing if required for framing or presentation.

Any sheet of paper that is going to be wetted in the process of completing the drawing (for example by the application of washes of tone or colour) will need stretching. This will stop the paper drying in an uneven, wrinkled state. The exception is heavy quality watercolour paper.

4 Ensure that the edges of the paper are flat to the board.

■ (c) using strips of brown gummed paper to tape down the edges.

Fold over the overlaps and leave to dry.

■ (d) leaving the paper to dry.

5 Use a wet sponge to press the tape in place if necessary. If the paper begins to wrinkle, let the tape follow the wrinkles – don't force it flat so that it creases. Allow the paper to dry in a flat position at room temperature.

You may want a general background tone or colour for your drawing. This can be done by dry-tinting with pastel or charcoal, working the shaded medium into the surface of the paper with a sponge. Alternatively, you can lay a wash over the whole area using diluted ink or paint applied with a very large brush or a sponge.

Different subjects and projects

At the start of each major project you will need to make an assessment of your aims for the drawing and decide how these are going to be realised. You will also have to consider how the decisions you make in respect of the desired approach and outcome will affect the techniques and media you should use, and consequently the paper or support to work on. Some projects will only need just a few quick sketches to resolve the idea and composition while others may require extensive research and preparation. Whatever the complexity of the proposed project, some preliminary thoughts and planning will normally prove a very worthwhile introduction to the idea, will identify any likely problems, and will establish a sense of purpose and the desired objectives.

Now look at illustrations 135 to 143 to see the sort of evolutionary stages a drawing may go through. Here are three entirely contrasting subjects developed with various media and having different aims. I have illustrated only three main stages for each piece of work: the development is gradual and many others could have been shown. Try some similar subjects for yourself and see how working through stages helps to develop the drawing confidently and successfully.

Exercises

1. Work on the theme of ruins or derelict buildings. Collect some research material in the form of personally observed drawings as well as photographs and other visual reference. Work from these to produce a large, well-resolved drawing on an A2 sheet of paper which uses contrasts of tone or colour to add to the drama and impact of the idea.

2. Try a series of preliminary studies of a cat, dog or other pet. Work from different viewpoints, spending about 10 minutes on each drawing. Get as much information as you can, including colour reference, and especially note particular features and characteristics. Use these to make one larger, well-finished study in colour.

3. Alternatively, work from a human model, relating the figure to the background. Follow the same procedure of preliminary sketches working up into a final drawing in colour.

Still life drawing

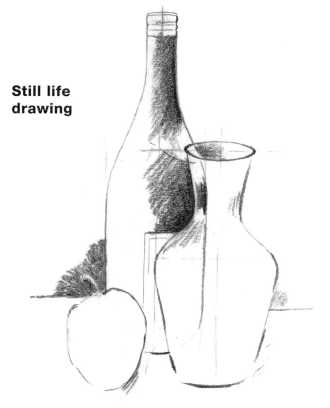

■ Illustration 135. Still life drawing. Step 1. Defining the principal shapes. *Charcoal and charcoal pencil.*

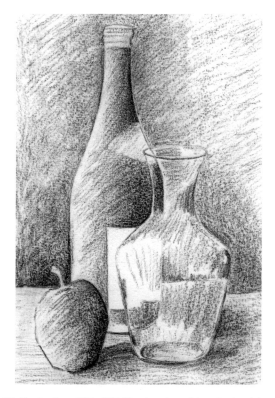

■ Illustration 136. Still life drawing. Step 2. Applying general areas of tone.

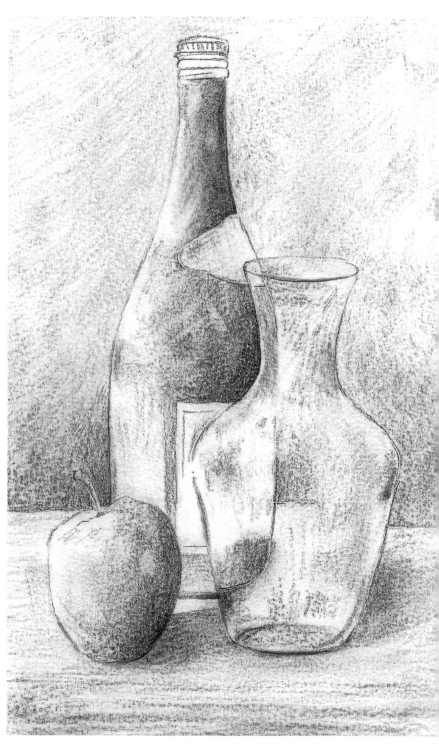

■ Illustration 137. Still life drawing. Step 3. Working over the drawing with a putty eraser to modify areas, model forms and create highlights.

Colour sketch

■ Illustration 138. Colour sketch. Step 1. Planning the composition and carefully drawing in the main shapes. *Pencil and coloured pencils.*

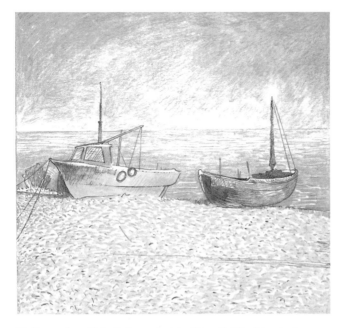

■ Illustration 139. Colour sketch. Step 2. Blocking in the general areas of colour.

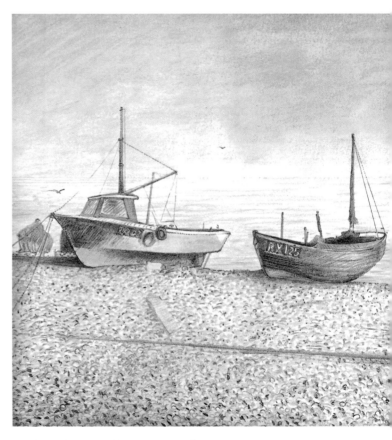

■ Illustration 140. Colour sketch. Step 3. Refining the colour and adding the necessary detail.

Location drawing

■ Illustration 141. Location drawing. Step 1. Plotting the main shapes and beginning to think about the strength and distribution of the different tones. *Pencil.*

■ Illustration 142. Location drawing. Step 2. Establishing the tonal values.

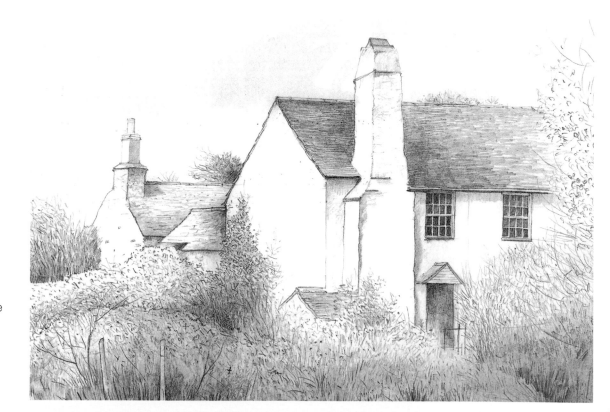

■ Illustration 143. Location drawing. Step 3. Developing the drawing with further tonal contrasts and details.

12

Developing your ability

Drawing offers something for everyone. There is a wide choice of different media, techniques and approaches and, of course, an inexhaustible supply of subject matter. With the confidence you have gained from practising the main techniques and processes you will now want to try out your own ideas and start to develop an individual way of drawing.

Getting to the point where you have a recognisable style and you are beginning to succeed in making the sort of drawings that truly reflect your ideas and feelings will naturally take time. To draw well and to make real progress requires much perseverance and practice. Ideally you should be drawing every day, even if this is only a 10-minute sketching session. Drawing is a combination of skill, perception and attitude. As well as the resolve to practise and persevere, you will also need the will to experiment and confront new ideas and the determination to tackle problems as they occur.

Whichever direction you take or path you seek to explore, your foundation skills will give you a good starting point. For many artists these skills remain at the focus of their work and, indeed, they are skills which can constantly be improved. With other artists the approach is gradually modified and developed away from formal values and the reliance on objective study and a representational outcome. However, basic skills remain important and influential and simply cannot be cast aside at a stroke.

Style is the distinctive or characteristic way of working which identifies a particular artist. Artists like Van Gogh or Picasso, for example, have no need to sign their work, for their signatures and personality are embodied within their drawings. Their style is immediately recognisable. In the main, artists do not set out to create a certain style, it evolves over a period of time. Your style will be the result of a combination of factors – the media and techniques you use, your subject matter, and your own personality and how you see and react to things. One of these factors often dominates. An artist's drawings may be instantly recognised because of the specific subject matter, for example, or an unusual technique. So avoid deliberately trying to create a style, let it grow naturally. As you pursue certain subjects, develop particular techniques, and draw with increasing freedom and confidence, so your style will gradually emerge.

Success in drawing relies on a breadth of experience. How else are you going to find out which subjects and techniques excite you the most? You have to test out

■ Illustration 144. Choose a medium that will help you convey those qualities which you feel are important about the subject – in this case atmosphere and a sense of place. *Coloured pencils.*

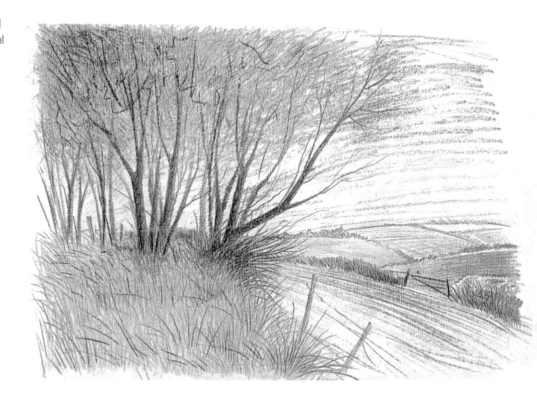

different ideas and approaches. And inspiration isn't always a bolt from the blue! In fact, sometimes the inspiration is not the initial reaction at all, but develops during the making of the drawing as you see an unusual, clever or alternative way of progressing. Inspiration is easier for more experienced artists, as they are better able to visualise the full potential of an idea, with probably a variety of ways of drawing it. But, whatever you are drawing, try to get fully involved and excited by it. If you are excited, the drawing is likely to show it and, in return, the finished work will excite other people.

Eventually you may want to specialise and concentrate on themes and subjects that especially appeal to you, but this should grow out of a good, general understanding of drawing. You will see from this chapter that drawings can rely on memory and imagination as much as on observation and analysis. You may also like to try an approach which selects and organises to create a more abstract outcome.

■ Illustration 145. Charcoal is the perfect medium for expressing striking tonal effects, as here.

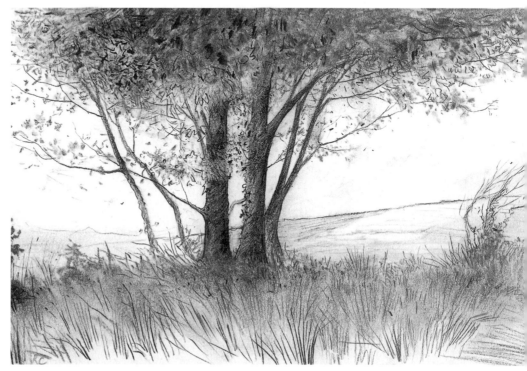

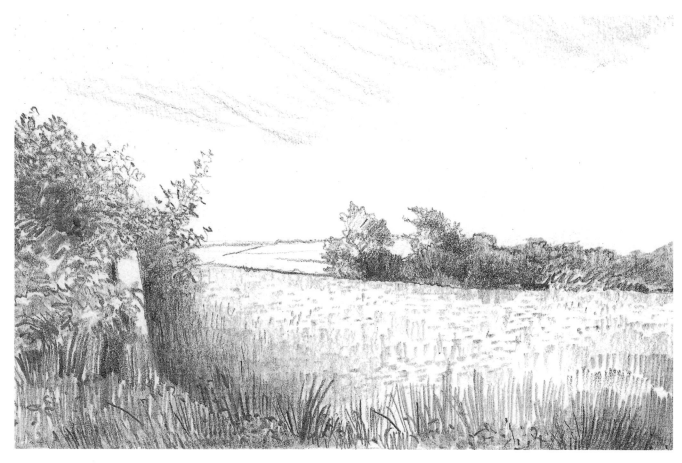

■ Illustration 146. A small pencil sketch, made on location, in which the focus of attention is on surface characteristics and textures.

Drawing and discovering

Even if you have planned your work very carefully, you are never quite sure what is going to happen once the drawing is under way. To an extent, every drawing is a voyage into the unknown, a voyage of discovery, and this is exactly as it should be. What you find out during the drawing process might be something about the subject matter, about the method or medium you are using, or about yourself. And although this discovery may seem very small in itself, it will inevitably add to your wider knowledge and skills.

It follows that the more you draw, the more you will discover. And the greater the scope of your subject matter and technique, the greater your drawing experience. So don't be afraid to attempt difficult ideas. Rather, see what you can find out by drawing them. Sometimes it is a good idea to do this by picking a subject at random. In addition, see what you can discover about effects and techniques by trying out a new medium.

Illustrations 144 to 146 demonstrate the importance of the medium in helping to convey particular intentions and qualities in a drawing. In these three examples you will see that the subject matter is very similar but that each drawing has been made with a different medium, thus enabling certain qualities and effects to be emphasised: feeling and atmosphere in illustration 144; the relationship of tones in illustration 145; and various surface textures in illustration 146.

Using your memory

Imaginative and fantasy ideas rely to some extent on working from memory and it is possible, of course, to make a drawing entirely from memory. Additionally, preliminary sketches and research drawings won't be able to contain every detail of the information you want and therefore you may have to use a certain amount of invention, experience and memorised information to complete the work. And sometimes you will find that time is against you when you are out and about sketching, preventing you from completing

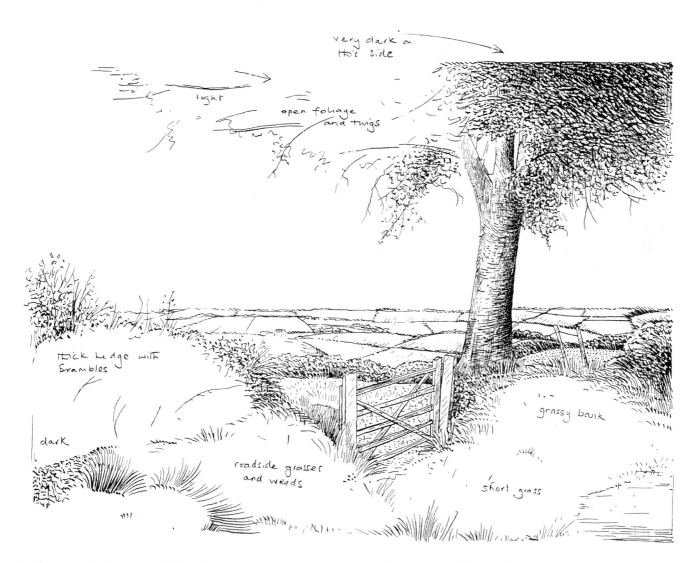

■ Illustration 147. With a detailed study there may not be enough time to finish everything on the spot and so you will have to rely on your memory. *Pen and ink.*

the drawing, especially if it is something quite detailed, as in illustration 147. The finished drawing must, therefore, use a mixture of observed fact, areas developed from notes and other reference material, and what you can remember.

So, as an artist, you need to train your memory; you need to have a good visual vocabulary, as it were, which you can refer to when needed. The way to improve your memory is to do plenty of observation drawings of a wide variety of subjects. Fill your sketchbooks with them. This will not only get you into the habit of drawing in such a way that you are looking, examining and understanding, but it will also mean that you are more likely to be able to recall those shapes and draw them from memory if need be.

Working from visual material

You can make drawings from photographs, magazines and newspaper cuttings, and other printed images and illustrations, but you do need to be careful how you use such material. There are artists who totally reject the idea of using second-hand imagery as source material. On the other hand, there are those who justify the projection of a transparency onto a sheet of paper so that they can draw around the outlines. There is probably a happy compromise.

Certainly, photographs can be useful from time to time. We have already seen that they can provide good back-up information in conjunction with sketches and other research drawings, especially if you want to explore different viewpoints and composition ideas or you need specific detail or colour reference. There are even occasions when the photograph could be copied – as part of a drawing where you require the exact detail, for example. But, on the whole, photographs are aids, starting points, and supplementary reference: they are not for copying.

There are two main reasons why you should not directly copy a photograph. The first is that your drawing needs to be your idea and as lively and spontaneous as possible. This is difficult if you are simply reworking a photograph. Secondly, photographs often distort distance and perspective and it becomes difficult to translate something like a view down a street, for example, into a convincing drawing. Obviously this may depend on the quality of your camera and your own photography skills, but you will notice in many photographs that vertical lines frequently tilt inwards and that the perspective of buildings and similar objects is exaggerated. Equally, depending on the camera and the processing, colours can be approximate to say the least.

In illustration 148 I have made a drawing from one of my photographs, but have altered the composition

■ Illustration 148. The reference for this drawing was a photograph, but I have combined the factual information it gave with my own knowledge of the subject and a little imagination or 'artistic licence'. *Coloured pencils.*

■ Illustration 149. Black and white photographs are very useful for showing general areas of tone which can then be simplified and interpreted in a colourful, abstract way. *Colour pencils.*

somewhat. Because this is a subject that I know well, I was able to draw it with some feeling and conviction, using the photograph only as a reminder and a starting point. The most important thing to remember when working in this way is that you are creating a drawing – not reproducing a photograph. So you need to be sensitive to the drawing process involved. There are many other ways that photographs can be useful, such as starting points for studying tone and shape or developing a selective or abstract result, as shown in illustration 149.

Fantasy and imagination

Many artists work from imagination rather than observation: they draw from ideas in their head rather than by sitting in front of objects or a scene. Whatever our approach or style, or our philosophy towards drawing, we all need to use imagination in our work to some extent. Now and again it is good for us and our work in general if we freely express ourselves in this way.

Inspiration for this sort of work might come from a number of sources: through particular interests, such as science fiction or mythology; from books, poems

and films; from travel; by interpreting observed subjects in a much more personal way; from the work of other artists; and by setting yourself a theme to research and develop in an imaginative way. Think how best to use techniques and media to add to the individuality of the work and remember that you may need to exaggerate, distort or use an unusual viewpoint or context in order to create the right feeling and impact in your drawing.

Abstract drawings

It is no doubt easier to see the validity and merit of creating a faithful likeness in a portrait drawing or capturing the atmosphere and feeling of a landscape view than it is to appreciate an abstract result. But not all abstract drawings are just a collection of careless lines and random marks! In fact, many of them result from applying a particular theory, restriction or emphasis to the drawing process. You might, for example, be interested in investigating the decorative quality of an idea by reducing it to a series of outlines that are all drawn with equal emphasis. Alternatively, you could view the subject purely in terms of three tones or colours, and so on. These processes not only produce some exciting results, but are very useful drawing exercises as well.

You can try three main approaches to abstract work: draw from observation but simplify, distort or select from what you see; use lines and geometrical shapes arranged in a deliberate composition and perhaps enhanced with tone or colour; or make random and uninhibited marks to create a free and expressive drawing. Do try some of these approaches because it does help your overall progress if your experience of drawing is catholic and wide ranging. Of course, in time, you will probably want to reject techniques, styles, and philosophies, but try to ensure that you do this from an informed standpoint, from a knowledge and experience of the things you are rejecting.

■ Illustration 150. Try some drawings which are pure fantasy and imagination. The repeated shapes in this design were made by using templates and tracings. *Fibre-pen*.

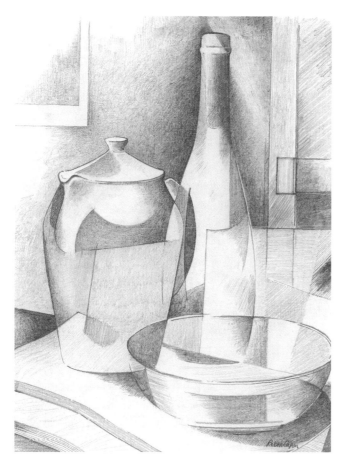

■ Illustration 151. Working with simplified shapes and flat areas of tone or colour will give a bold, semi-abstract result, as here. *Pencil*.

■ Illustration 152. Various media have been combined in this freely expressed abstract drawing, including pencil, coloured pencils, pastels, ink and felt-tip pens.

My drawing in illustration 151 was worked from an actual subject studied objectively. But, because I have concentrated on a limited range of flat tones related to equally assessed foreground and background shapes, the result is semi-abstract. Contrastingly in illustration 152 I have combined various media in a freely expressed drawing, while a collaged technique has been used in illustration 153. The original drawing was cut into strips then arranged and glued to a backing sheet. Your abstracts can use an intellectual, ingenious or imaginative approach, can be fun, and at the same time can help you discover much about materials and methods.

Evaluation

The drawing process is one in which you are constantly making judgements. You are, in effect, being self-critical all the time. For example, you will need to question whether you have made a line too long, whether something is too big, whether a shadow should be a little darker, and so on. At the end of each drawing try to spend a few minutes looking at it and assessing its success. Does it fulfil its aims? If it is a preliminary sketch, does it provide enough

■ Illustration 153. Collage design. The original drawing was cut into strips, rearranged, and glued to a backing sheet of card. *Coloured pencils.*

periodic evaluation could take the form of a display of all your recent work. By looking at 10 or 20 drawings you can make a better judgement about weaknesses in technique and the sort of things you ought to be practising more, as well as the strengths and interests you should be building on. This kind of assessment helps in making decisions about the future direction of your work and the particular aspects you should be concentrating on.

Constructive self-criticism isn't easy. There is a happy balance between being blasé and expecting everything to righten itself, and being zealously critical to the point of abject depression! Try to justify criticisms and decide on remedies. It could be simply a matter of more practice or revision, or of seeking additional help from books, videos or tuition.

It can also help to get other people's opinion of your work. If you know other people who draw and sketch, get together for a shared evaluation session. Alternatively, join an art society or club, or enrol on a life class or other drawing course. This will give you the opportunity to meet other artists, both amateur and professional, and to exchange views and ideas.

information to work from? If it is the main drawing, has it got the sort of feeling, effects and impact that you were aiming for?

In addition, it is important and helpful to keep your eye on your general progress and development. A

Exercises

1. Develop two drawings, on A2 sheets of paper or larger, on the theme of 'Light and Dark'. In the first drawing work as much as possible from imagination and aim to express the theme in a very individual and personal way. For the second drawing work from a still life group, making tone (and/or colour) the prime interest in your drawing. For both drawings consider the best media to use and whether your idea would be more effective in colour or on coloured paper.
2. Make an evaluation of your last 10 drawings. In your notebook or sketchbook, jot down any obvious weaknesses and suggested remedies.

Looking at drawings

As well as being very enjoyable and rewarding, looking at a variety of drawings made by other artists will help inspire and inform ideas in your own work and teach you a great deal about selecting subjects, using techniques and presenting drawings to the best advantage. Viewing and evaluating other people's work plays a key part within the breadth of approach towards learning to draw that is recommended in this book.

Looking at drawings is, therefore, a good habit to develop. So try to view a wide range of work – drawings by your friends as well as those of the great masters. Visit exhibitions, galleries and museums. Go to local exhibitions as well as to see the collections at the British Museum, Courtauld Institute, Ashmolean and other major galleries. In fact, many provincial museums have a surprisingly large and interesting collection of drawings to view. And start your own collection of postcards, reproductions, cuttings and books.

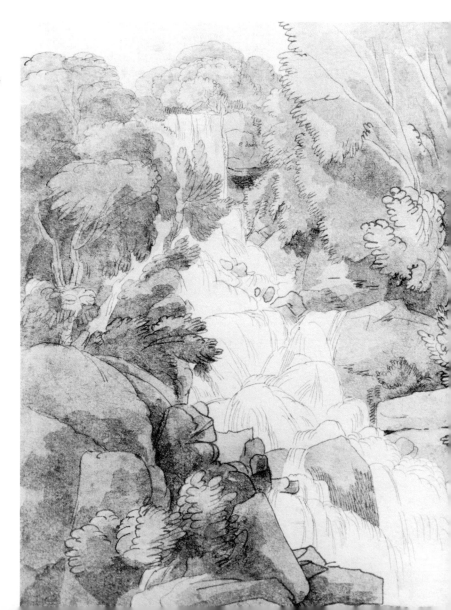

■ Illustration 154. *A waterfall, near Vevey, Switzerland 1781* by Francis Towne. *Pen, ink and monochrome wash.* Exeter City Museums and Art Gallery.

Historical context

Throughout history artists have used whatever tools and techniques were available to express their observations, thoughts, emotions and anxieties in the form of drawings. Cave drawings date back to earliest man, some 40,000 years ago. Many of these early drawings were decorative, being scratched on to pottery, walls or columns, for example, or engraved into metal or carved from wood. Few examples of drawings on paper or parchment exist before the sixteenth century.

The 'modern' age of drawing began with the invention of printing and the woodcut. Artists like Dürer could reach a much wider audience through their illustrations in books and as separate reproductions. But it was during the Renaissance period of the fifteenth and sixteenth centuries that drawing was seen as an art form in its own right and as the basis for all art. Uccello, Leonardo da Vinci, Michelangelo, Raphael and Holbein were among many notable artists of that time who sought to perfect devices such as perspective, find means of achieving correct proportions, and explore techniques like silverpoint, chalk and charcoal drawing.

As in many other art forms, the history of drawing reflects the outlook and wealth of different ages. There are periods when portrait drawings were fashionable and others when artists were more concerned with nature, religion or the mysteries of the universe. There were times of reaction and invention as well as of celebration and consolidation. Obviously the history of drawing is a very extensive subject, so if you come across well known artists whose drawings you find interesting and inspiring then do a little detective work of your own. See what more you can find out about their life and work. Study their subjects and techniques; maybe these will influence your own drawings. Clearly some artists will appeal to you more than others, but find time to borrow books from your local library and begin to develop an appreciation of different artists and styles.

You will see some master drawings in this section. These have been chosen to demonstrate different styles and approaches and you will notice that they are not all highly finished drawings. Study them to see what you like or dislike about the subject matter, composition, use of media, impact and so on, and whether they can provide any indicators for your own drawings. A comprehensive list of other famous artists to look at would be extremely lengthy, but I can recommend the following for consideration: Poussin, Claude Lorrain, Rubens, Rembrandt, Gainsborough, Goya, Daumier, Degas, Cézanne, Gaugin, Toulouse-Lautrec, Matisse, Picasso, Klee and Hockney.

Looking and learning

As an example, let's look carefully at the drawing by Canaletto in illustration 155. Venice is a city with

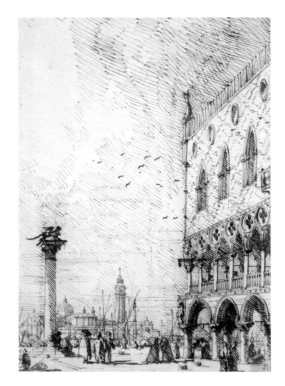

■ Illustration 155. *Doge's Palace overlooking S. Giorgio Maggiore* by Antonio Canaletto. *Pen and brown ink on toned paper.* The Royal Collection © 2001 Her Majesty Queen Elizabeth II.

elegance, history and atmosphere which has attracted artists for many centuries. This view from a corner of the Doge's Palace looking into St. Mark's Square is a favourite one with artists. So, is this a good drawing? And if so, why is it, and what can we learn from it?

I stressed in an earlier chapter the influence of such fundamentals as size, technique and the type of paper in determining the outcome and impact of the drawing. Reproductions in books are seldom of the same size and quality as the original, of course. We should bear in mind that the actual Canaletto drawing is 27 x 19 cm and that it is made in pen and brown ink on a toned paper.

Although, like many of Canaletto's drawings, this view was probably completed with the help of a camera obscura (a device used to ensure accurate outlines and perspective), the drawing has a feeling for space and atmosphere. It is a sensitive drawing with wonderfully deft pen touches, especially in the arcading of the palace. Notice how lines, birds and pen strokes create a sense of movement and vigour. Shadows and contrasts of tone and scale give a remarkable feeling of depth within a very confined area.

The majesty and scale of the buildings are enhanced by the carefully grouped figures which additionally, with their shadows, give interest to the foreground. A close look at these figures shows that they are suggested with just a few pen lines, rather than being worked in great detail. So, too, with some of the shadow effects – look at the hatched lines on the column and under some of the arches. Our attention is maintained within the picture area, we are led to a distant focal point, and there is plenty to interest us both in subject matter and technique. In consequence, the drawing works: it is a good drawing.

These are just a few points about the Canaletto drawing. They illustrate the sort of things we can look for in a drawing and show how by looking, analysing and trying to understand we can develop a greater appreciation of drawings and pick up tips and ideas for our own work.

Something else we should bear in mind as we look at a drawing is the artist's aim or intention. The Canaletto

drawing, for example, is a carefully observed study. How, then, does this approach compare to the other master drawings illustrated in this chapter? Look closely at the two contrasting figure drawings in illustrations 157–158. In each case note how the artist has chosen a particular medium and technique to suit a certain intention for the work. And remember that when you look at drawings in this way, try to put your own preferences aside for a moment: try to view each drawing on its individual merits.

Inspiration and ideas

Look at the pose in illustration 157, the technique in illustration 156, and the power and vigour in

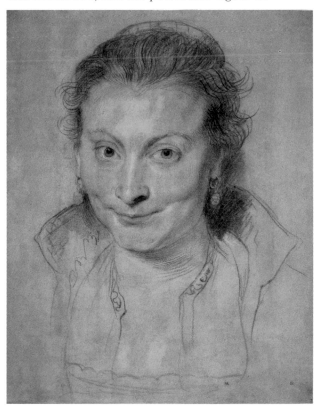

■ Illustration 156. *Portrait of Isabella Brant* by Peter Paul Rubens. *Black, red and white chalk with light washes on light brown paper. Eyes strengthened with pen and black ink.* © copyright The British Museum.

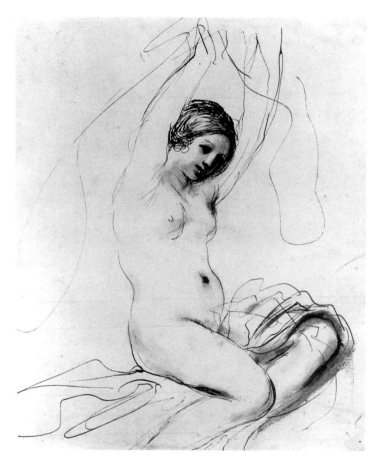

■ Illustration 157. *Study of a Woman Bathing* by Giovanni Guercino. *Pen and wash.* © copyright The British Museum.

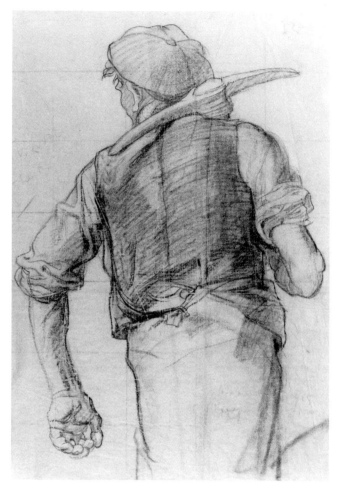

■ Illustration 158. *Miner* by Frank Brangwyn. *Black chalk.* Blackburn Museum and Art Galleries.

illustration 158. As we view other drawings, there are sometimes aspects which spark off ideas for exploration in our own work. Looking at other artists' drawings helps us to form opinions and shape our own philosophy and outlook. Equally, they can be inspirational, can clarify a problem that we have been struggling with for some while, or will provide us with a fresh way forward.

While there are benefits from studying other drawings, I should not want to give the impression that we should always look at drawings simply to see how they can help us. Drawings are for enjoyment as well, and remember, to fully appreciate a good drawing you may need to look at it many times.

Exercise

1. Study carefully the five drawings in this chapter and choose the one that gives you the most pleasure and the most inspiration? Make a drawing of your own, inspired by the subject matter, technique or some other aspect of the drawing you have chosen.

Framing and presentation

Many of your drawings will be reference studies and development sketches rather than exhibition pieces. However, as your work improves and you make some drawings which are particularly successful, you will want to mount and frame one or two. You could display these in your home or even exhibit them. Drawing is, after all, a means of communicating ideas to other people – so your work should be seen.

Preparing the drawing

Having selected a drawing to frame, check it over to see if there are any final details or alterations you would like to make. Clean off unwanted marks and if necessary spray the drawing with fixative. This will protect soft, smudgy techniques, such as charcoal and pastel, and prevent them offsetting and spoiling. Fixative is a type of thin varnish. It is available in aerosol containers or it can be bought in liquid form and applied with a metal spray diffuser. Spray the drawing in a well ventilated room, from a distance of about 30 cm. Start at the top and work across and downwards. Spray lightly and allow the work to dry. Test a corner to see if the drawing will still smudge and, if so, apply a further coating of fixative. Next, trim the drawing to a size that leaves at least a 2.5 cm margin as overlap for the mount.

The way that a drawing is presented is a matter of personal preference: some people like the drawing to hang naturally and are not bothered by any slight surface undulations, while others prefer it to be absolutely flat. Drawings on thin paper may need backing before fixing them to a mount. This is done by gluing the drawing to a sheet of thicker paper or card. Choose a card with a low pH value, preferably acid-neutral. Suitable types of card are available at art materials shops and framers. Use a wheat starch powder or water-soluble PVA adhesive, both of which have a neutral pH value.

For drawings that need a backing support, follow this procedure:

- Choose a sheet of thin, acid-neutral card slightly larger than the frame and mount you intend using for the drawing.
- Place the drawing (which will include a slight margin around the edges as an overlap for the

mount) as near as you can judge in the centre of the sheet of card – such that there is an equal margin top and bottom, and at both sides.

- Mark the position of the drawing paper on the card with some pencil lines.
- Quickly apply a thin, even coating of adhesive to the area within your pencil lines.
- Lower the drawing in place and, again working quickly, press down on some offcuts of clean paper to smooth out any wrinkles that appear. Work from the centre to the edges and press firmly.
- Place the drawing under a drawing board or similar heavy board and put a few heavy books on top for extra weight. Allow the backed drawing to dry under pressure for 24 hours.
- Take the mount you have selected and place this over the drawing. Use one or two dabs of PVA adhesive to hold the mount in place.
- Trim off any surplus backing card that shows around the edges of the mount.

Choosing mounts

Mounts and frames serve both a practical and an aesthetic purpose. Drawings need the protection of glass and, in addition, the mount and moulding should help focus attention on the drawing and enhance its presentation. Therefore, in your decisions about framing a work you need to consider the complete combination of drawing, mount and frame. You may want to mount and frame your drawings yourself or have this work done professionally. Whatever you decide it is a good idea to get some offcuts of mounting card and make right-angle shapes, like those suggested for cropping a drawing on page 92, so that you can try out various colours and types of card. Place them around your drawing to check which colour looks best. Also, if you can beg or buy a few scrap lengths of different framing mouldings from your local picture framer, you can use these in conjunction with the sample mounts to get a fairly accurate impression of the combined effect of mount and

frame. In your deliberations you will need to consider whether you need to use a single, double or oval mount as well as which colour and texture works best.

The mount is usually cut so that it has a slightly wider margin at the bottom than at the sides or top. The width of these margins will depend on the content and impact of the drawing. As an example, an A3 drawing will need margins of about 6.5 cm, with 7.5 cm at the bottom.

- Illustration 159. Cut the mount so that it has a slightly wider margin at the bottom than at the sides and top.

You can cut a simple window mount with a sharp craft knife used against a metal straightedge. First cut the card to suit the dimensions of the frame. You can mark off the margins of the mount on the back of the card and then cut out the centre piece, or work from the front. Mounts depend on accurate measuring, clean, straight lines, and precise right-angles. Badly made, they will only detract from the drawing rather than enhance it. As you handle and measure the card, be careful not to mark or damage it in any way.

Cutting from the front of the mount often gives a neater finish. Begin by marking off the width of the side margins with faint pencil lines along the top and bottom edges,

use a double mount, as in illustration 160. Fix the drawing to the mount with double-sided framer's tape.

There is a huge variety of mounting cards and boards to choose from. Avoid any that are not acid-free, as these may cause some discolouration to the edges of the mounted work over a period of time. There are also problems with the light-fast quality of some cards. Ideally you should use a good quality neutral pH board, such as Daler Studland Board. Similarly, where work is taped to the back of a mount, an acid-free framing tape should be used.

If you lack the time, confidence or equipment to have a go yourself, then discuss any ideas for mounting and framing your drawings with a professional framer.

Choosing frames

Like mounts, frames need to be of a high quality if they are to complement the drawing to the best effect. You may be interested in buying all the necessary equipment and making your own frames. Alternatively, you can have frames made to suit your own specifications at a framer's or craft shop; you can renovate old frames bought from junk shops and market stalls; you can use frame kits or clip frames; or you can buy cheap framed prints, replacing the print with your mounted drawing. You can also order frames by post. Send for samples and details to check the quality and suitability before placing an order.

The choice of the frame moulding should obviously relate to the size and type of drawing, as well as the mount. Small drawings often look best with a plain, narrow moulding in natural wood, while larger works can take something proportionately wider. You might decide to use a plain coloured moulding for an abstract, whereas a detailed still life might look better in a more ornate frame. Have a look round some galleries and exhibitions to see how other artists have framed their drawings. This will give you some ideas for your own work. Illustration 162 shows how the mount and drawing are assembled within the frame.

■ Illustration 160. Some drawings will benefit from the use of a double mount. This usually has a narrow inner strip (perhaps measuring between 5 to 10 mm) of a slightly contrasting colour to the main outer border. Similarly, a stepped effect, using the same coloured mountboard for both inner and outer mounts, can look interesting. Double mounts often give a more pleasing, professional look and another advantage is that the narrow inner mount will form a useful defining and unifying edge to the drawing. Use double-sided framer's tape to fix the two mounts together.

then place a perspex rule across the card and, with a pin prick, mark the actual corners of the part to be cut out. Finally, cut out the centre shape using a very sharp knife against a metal rule, working on a cutting mat.

Ideally, if you decide to make most of your own mounts you will need to invest in a good quality mount cutter. This will enable you to produce professional-looking results. Mount cutters are available from artists' materials shops: ask for a demonstration. Practise on some card offcuts first.

Work can also be flat-mounted, that is trimmed to the exact dimensions of the drawing and glued to a backing sheet of white or coloured card cut to a size that will give a border around the drawing, or you can

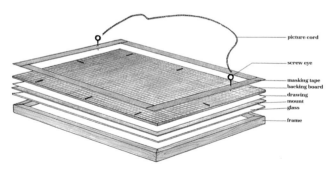

■ Illustration 162. Assembling the mount and drawing in the frame.

■ Illustration 161. Frames, a double mount, and framing accessories.

Making frames

If you have basic do-it-yourself skills and intend framing a large number of drawings, you may want to make your own frames. The main benefit of this is that, apart from the satisfaction of having created both picture and frame, you can produce something exactly to the specification you require for the drawing. Here, in addition to some basic woodworking equipment you will need a good-quality mitre saw, a frame clamp, an underpinner, a brad gun and a glasscutter. These can be purchased from some art and craft shops, hardware shops or through specialist suppliers. Additionally, you may find that some framing courses are available locally in the form of evening or day classes run by an adult education centre, and that other course centres are advertised in art magazines and directories.

Displaying drawings

It is satisfying to see some of your drawings displayed around the house. Where and how they are hung is, of course, a matter for your own judgement, but there are one or two points to bear in mind when considering the siting of pictures.

Avoid placing a framed drawing in a position where it will get a lot of full sunlight, as eventually exposure of this sort will cause fading and discolouration, both to the mount and the drawing. In fact, the position of a picture with regard to the source of light, whether natural or artificial, is important. If it is placed such that the picture glass reflects various other items or parts of the room, the drawing will be difficult to view. As a rough guide, where possible, hang pictures so that the centre of the drawing is slightly below your eye level. Drawings often look better if arranged and displayed in groups rather than in isolation, particularly if they are small. The other point to watch out for is humidity and dampness. A framed drawing placed against a cold stone wall, for example, will gradually pull out any dampness from the wall, or alternatively, trap condensation. Check the backs of frames occasionally to see if there are any signs of dampness.

Glossary

Aerial perspective The influence of the atmosphere on a distant view so that objects appear less distinct, tonal contrasts muted, and colours weaker and cooler. Colours often seem to acquire a bluish tinge as they recede.

Airbrush A mechanical tool for creating finely controlled spray effects. Compressed air from a canister or compressor is mixed with the paint and directed through an adjustable nozzle to make the spray.

Asymmetrical A design or shape which, when divided along its central axis (more or less in half), is not identically balanced.

Bistre A brown pigment made from the soot of burnt beechwood. Bistre was once used in wash drawings to create various transparent tonal effects.

Bleed The blurring of the edges of a line or shaded area caused when two wet areas meet, a wet wash undercuts a dry charcoal or pastel area, or a wet medium is applied over a dry one. This can also happen when ink or brush lines are applied to the wrong sort of paper.

Blending The fading of one colour into another or the working together of adjacent areas of shading or tone to create a gradual transition from light to dark. Blending is best achieved with a soft drawing medium such as charcoal, pastel or a 6B pencil.

Centre of vision The point on the horizon or at eye-level which is immediately in front of you. This need not be in the middle of the drawing because your viewpoint could be from one side.

Chiaroscuro Dramatic contrasts of light and dark, as for example in the drawings of Leonardo da Vinci and Rembrandt.

Cockling (Buckling) Uneven paper surface after applications of wash or spray.

Composition The way you arrange the various shapes and content of your drawing into a particular design.

Contour drawing Concentrating on the outlines of the different shapes.

Draughtsmanship Skill in drawing.

Elements of drawing Line, point, tone, texture, colour, form, size, shape and pattern.

Eye-level An actual or imagined horizontal line in a drawing which represents your line of vision in relation to the subject and shows the position from which your viewpoint is taken.

Fixative A kind of very thin varnish which is sprayed over soft pencil, charcoal and pastel drawings to prevent them smudging.

Focal point The object or part of the drawing that most attracts your attention. Usually the design or composition is so devised that shapes and lines lead your eye to a particular point.

Foreshortening The influence of perspective on an object coming directly towards you, such as an outstretched arm. This gives a very obvious contrast in scale between the nearest part and that furthest away.

Form The three-dimensional shape of something.

Foxing Brown spots on a drawing caused by exposure to dampness.

Golden Section The use of a mathematical proportion of approximately 5:8 in the composition of a drawing. Therefore, the focal point or most obvious feature comes on a line roughly five thirteenths of the way across.

Gradation The gradual transition from light to dark shading without any noticeable edges.

Grid Division of the drawing into squares to help with the organisation of the composition and scale, or for enlarging.

Hatching Short, closely spaced straight lines used to suggest shadows or texture. The lines are usually slanting and the closer they are together, the more intense is the shading effect. In cross-hatching, a series of lines drawn in one direction is overworked with others in the opposite direction.

Highlight The very lightest area in a drawing. A part that attracts or reflects the greatest amount of light.

Horizon line A horizontal line, drawn or imagined, which represents your eye-level and the furthest point of sight on the ground area.

Image An object or figure. The general shape and likeness of something.

Landscape As well as drawings of the open countryside, this relates to the general shape of a drawing in which the horizontal measurement is significantly greater than the vertical one.

Lay figure A jointed, wooden model used to help with human proportions and poses.

Masking fluid A rubber compound solution that is painted on to particular areas to protect them from general wash or spray applications. You can use it to 'save' highlights, fine lines and small details. It can be applied at any stage in a drawing, either to preserve patches of white paper or a later colour or effect. When the drawing is finished the masking fluid can be rubbed off or picked away.

Medium Any drawing material, such as pencil, charcoal, pastel, and ink.

Mixed media Using several different drawing tools or materials within the same drawing.

Monochrome A drawing in black and white or confined to a range of tones of one colour.

Monotone Using a single tone (shade), plus areas of white; normally black and white.

Natural forms Shells, bark, plants and other objects found in nature.

Objective drawing A drawing in which the intention is to be as accurate as possible and to show a real likeness of something.

Overworking Adding more work, perhaps in a different medium or technique, over lines and tones already completed.

Perspective A technique for creating the illusion of distance and space.

Proportion The size of one object in relation to others. Also, the size of one part of an object in relation to other parts and to the object as a whole.

Register Keeping one sheet of paper exactly in the right position in relation to a sheet beneath, when making monoprints, tracings and copies.

Representational drawing A drawing which shows something exactly as you see it.

Sfumato The careful blending of delicate areas of shading so that there is no obvious distinction between one tone and the next.

Sgraffito Drawings made by scratching through one layer of colour or tone to reveal a contrasting one beneath. For example, you can scratch lines into black ink which has been applied over coloured wax crayon.

Shading Creating light and dark areas in a drawing to give the effect of shadows and the illusion of three-dimensional form.

Stippling Creating tone or mixed colour by holding a brush, pencil or pen vertically and stabbing it up and down to produce an area of fine dots.

Stretching paper Preparing paper by taping it to a board, so any subsequent washes of ink or paint do not distort its surface.

Support Anything used to draw on, like paper and card.

Symmetrical A completely balanced composition or shape. If divided in half, one half would be a mirror image of the other.

Technique The process of working in a particular drawing medium or the individual method of using that medium, such as hatching, stippling or linear.

Thumbnail sketch A very small sketch just to show the simple outlines of an idea.

Wash Ink or paint diluted to a very fluid state and lightly applied over the paper surface.

Vanishing point Lines used in perspective will appear to converge to a point on the horizon or eye-level, known as the vanishing point.

Index